DENNIS STOCK MADE IN USA

DENNIS STOCK

CANTZ

MADE IN USA

PHOTOGRAPHS 1951–1971

CANTZ

© 1995 Dennis Stock
für sämtliche Photographien
for all photographs

Seite / Page 7 »The Photojournalist«
by Andreas Feininger
© 1994 Life Magazine, Time Inc.

Herausgeber / Editors
Thomas Buchsteiner,
Markus Hartmann

Ausstellungsorganisation
Exhibition curated by
Institut für Kulturaustausch,
Tübingen

Lektorat / Copy editing
Cornelia Plaas

Übersetzungen / Translations
Cornelia Plaas, Birgit Herbst

Gestaltung / Layout
Karin Girlatschek,
Dennis Stock

Lithographie / Separations
C+S Repro, Filderstadt

Gesamtherstellung / Printed by
Dr. Cantz'sche Druckerei,
Ostfildern

ISBN 3-89 322-639-7

Cantz Verlag
Senefelderstraße 9
73760 Ostfildern
Tel. (0)7 11-44 99 30
Fax (0)7 11-441 45 79

Vertrieb in den USA durch
Distributed in the USA by
Distributed Art Publishers
Broadway 636, RM 1200
USA-New York, N.Y. 10012
Tel. 2 12-4 73 51 19
Fax 2 12-6 73 28 87

Umschlagvorderseite / Front cover
Rock Festival, Venice Beach

Die Ausstellungstournee
wurde von der DG BANK
ermöglicht.
The traveling exhibition
has been made possible
by DG BANK.

Printed in Germany

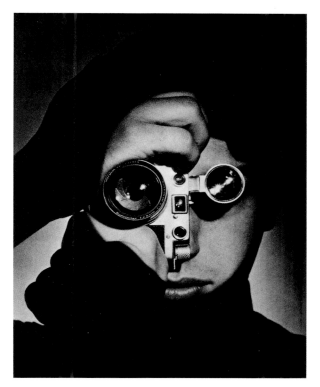

Andreas Feininger, Portrait Dennis Stock, 1951

THANK YOU

GJON MILI,
W. EUGENE SMITH,
ERNEST HAAS, AND
HENRI CARTIER BRESSON

Dennis Stock

VORWORT

Die Musik brachte uns auf Dennis Stock: wir kannten das legendäre Buch »Jazz Street« über die amerikanischen Jazzgrößen der späten fünfziger Jahre, die Dennis Stock beeindruckend photographiert und Gerd Hatje 1959 in einer deutschen Ausgabe verlegt hatte. Wir kannten auch andere Arbeiten Stocks, zum Beispiel seine Aufnahmen von James Dean, mit denen er Photogeschichte machte.

Die Idee, eine Ausstellungstournee mit der Neuauflage von »Jazz Street« zu verbinden, führte im Frühjahr 1993 zu einem ersten Gespräch mit Dennis Stock. Als er uns damals eine größere Auswahl seiner zum Teil berühmten Schwarzweißaufnahmen vorlegte, entwickelte sich aus der ursprünglichen Vorstellung sehr schnell eine umfassende Publikation und Ausstellung der eindringlichen Photoessays. Etliche der hier gezeigten Bilder, die uns schon einmal irgendwo begegnet waren, hatten wir bis dato nicht mit Dennis Stock in Verbindung gebracht.

Im Leben jedes guten Photographen gibt es hin und wieder einen »Volltreffer«, eines jener seltenen »big pictures«, die, vielfach publiziert, eine Karriere wesentlich beeinflussen können und schnell in das kollektive Gedächtnis ihrer Zeit eingehen. Diesen Bildern gelingt es, exakt zum richtigen Zeitpunkt im Bruchteil einer Sekunde das Charakteristische einer Person, einer Bewegung, eines Lebensgefühls zu bannen. Sie überdauern Jahrzehnte und bleiben in der Erinnerung der Beteiligten, aber auch späterer Generationen haften. Unter den in diesem Buch abgedruckten Bildern finden sich weit mehr von diesen »big pictures«, als wir ursprünglich erwartet hatten. Wir möchten diese und die anderen, stilleren, aber nicht weniger konzentrierten Bilder mit dem Namen des Photographen in Verbindung bringen, der für ihr Entstehen verantwortlich ist – Dennis Stock.

Die in diesem Buch vorgestellten Arbeiten fallen in die große Zeit des engagierten Photojournalismus, dessen Zukunft in der hier gezeigten Form nicht mehr gesichert scheint. Die Kraft der Bilder entfaltet sich heute »multimedial« im krassen Gegensatz zur reduziert konzentrierten Schwarzweißphotographie der fünfziger und sechziger Jahre.

Dennis Stock ist selbst ein Teil dieser Entwicklung. Seine Karriere als Photograph begann kurz nach dem Krieg. Er hat sich in den letzten Jahren von der Schwarzweißphotographie, die ihn bekannt machte, zugunsten der Farbphotographie gelöst und interessiert sich zunehmend für die Sprache des Films, die Videotechnik und die damit verbundenen multimedialen Anwendungsbereiche.

Die Photographie ist heute nur noch eine von vielen Möglichkeiten der Information durch das Bild. Die Herausgeber hoffen, an die Bedeutung des Photojournalismus zu erinnern, wenn sie jetzt einen der Großen des Fachs, Dennis Stock, mit dieser sorgfältigen Auswahl seiner Bilder einem größeren Publikum vorstellen. In diesem Zusammenhang weisen wir auf ein berühmtes Bild von Andreas Feininger hin, das den Titel »The Photojournalist« trägt und den jungen Dennis Stock, stellvertretend für seine ganze Zunft, hinter der Kamera zeigt.

Wir möchten allen an der Ausstellungstournee beteiligten Museen für ihr spontanes Engagement danken, der DG BANK für ihre großzügige Unterstützung, allen am Projekt Mitwirkenden und natürlich Dennis Stock, der uns im Laufe der Vorbereitungen und während der Zusammenarbeit ein Freund wurde.

Thomas Buchsteiner, Markus Hartmann

FOREWORD

Music brought us to Dennis Stock: we knew "Jazz Street," the legendary book containing Dennis Stock's impressive photographs of great figures in late-fifties America, published in a German edition by Gerd Hatje in 1959. We knew other work by Stock as well, like his photographs of James Dean, which made photographic history.

The idea of combining an exhibition tour with a new edition of "Jazz Street" led to a first meeting with Dennis Stock in spring 1993. He showed us a large selection of his black-and-white photographs on this occasion, some of them famous, and the original idea very quickly developed into a plan for a comprehensive publication and exhibition devoted to these powerful photo-essays. We had previously encountered a number of the images presented here in various places, but so far had not connected them with Dennis Stock.

Every so often there's a "bull's eye" in the life of every good photographer, one of those rare "big pictures" that are published over and over again. They can have considerable influence on a career, and rapidly enter the collective memory of their age. Such pictures successfully capture the essence of a person, a movement, or a feeling at precisely the right moment, in a fraction of a second. They last for decades, and linger in the memories of those involved and of later generations. The images reproduced in this book include far more of these "big pictures" than we originally anticipated. It is our intention to link these and the other, quieter but no less concentrated images more firmly with the name of the photographer who was responsible for their creation – Dennis Stock.

The work presented in this book dates from the great age of committed photojournalism, whose future no longer seems secure in the form shown here. Today the power of images emerges in "multi-media" guise, in stark contrast to the reductive concentration of fifties and sixties black-and-white photography.

Dennis Stock is himself part of this development. His career as a photographer started shortly after the war. In recent years he has abandoned the black-and-white photography that made his name in favor of color photography. He has become increasingly interested in the language of film, in video technology and their multi-media applications.

Today photography is only one of many ways of conveying information through images. The editors hope to provide a reminder of the importance of earlier photojournalism by presenting one of its great exponents, Dennis Stock, to a wider public with this careful selection from his work. It is no coincidence that a famous picture by Andreas Feininger called "The Photojournalist" shows the young Dennis Stock behind the camera, as a representative of his whole profession.

We should like to thank all participating museums for their spontaneous commitment, DG BANK for its generous support, everyone involved in the project, and of course Dennis Stock, who became a friend during the preparations and our work together.

Thomas Buchsteiner, Markus Hartmann

DENNIS STOCK ÜBER DENNIS STOCK

Mit jedem guten Photo ist immer eine Entdeckung verbunden: Das geschieht besonders dann, wenn der Photograph sich selbst vergißt und sich wie ein Kind zu wundern vermag. Das Ergebnis wird dann unmittelbarer und lebendiger.

Um als Photograph Erfolg zu haben, muß man beweglich bleiben. Immer wieder die Sichtweise zu wechseln, und die tiefe Überzeugung, einen ganz eigenen Blick für die Dinge zu haben, bringt einen voran. Einfühlungsvermögen für das, was man aufnehmen möchte, spielt eine wichtige Rolle. Dem Wesen der Photographie in der Schönheit, im Leid und im Humor auf die Spur zu kommen, ist entscheidend, wenn man sie passioniert betreiben will.

Ich bin kein Gelegenheitsphotograph. Bestimmte Themen motivieren mich, die Kamera in die Hand zu nehmen, und im Grunde bin ich mehr Photoessayist als Photojournalist.

Es gibt viele Photographen, die ich bewundere, aber W. Eugene Smith steht für mich an erster Stelle. Sein fanatischer Drang, die Wahrheit herauszufinden, hat mich in meiner Arbeit am meisten beeinflußt. Ich habe hauptsächlich Themen mit einem großen Spektrum an visuellen Ausdrucksmöglichkeiten gesucht, außerdem wollte ich damit neue Erkenntnisse gewinnen. Ich vertiefe mich gerne mit Ausdauer in ein Thema, um sämtliche Möglichkeiten und Aspekte, die es bietet, auszuloten, und bereite mich auch geistig gründlich darauf vor. Es ist sehr schwer zu entscheiden, welches Thema ausreichende graphische Möglichkeiten bietet und mich wirklich fesselt.

Ich bin ständig dabei, mich selbst herauszufordern. Für jeden Essay muß man zunächst recherchieren, im Grunde geht es aber vor allem darum, sich mit dem richtigen Thema auseinanderzusetzen und der eigenen Intuition beim Photographieren die Führung zu überlassen. Wenn man die Chance für ein gutes Photo wittert, heißt es warten, warten, warten. In einem kurzen Moment ergreift man sie dann wie ein Raubtier und genießt den Augenblick. Meine Essays dienen mir als Tagebuch voll interessanter Begegnungen, oft gibt es sie dann tatsächlich in Buchform – so werde ich ständig auf wunderbare Weise daran erinnert, wo ich gewesen bin.

Die Leute, die ich photographiere – Biker, Hippies, Vagabunden, Künstler –, sind einfach Menschen, die nur auf eine etwas unangepaßtere Weise mit diesem schwierigen Leben umgehen, das wir alle führen müssen. Ihre Art als Individuen zu leben hat mich so fasziniert, daß ich die Kamera nicht ruhen lassen konnte. Wenn man wie ich zwanzig Jahre lang Menschen photographiert, muß man hin und wieder seine Methode ändern, damit das Ergebnis lebendig bleibt. Ich bin zutiefst davon überzeugt, daß man Menschen am besten in Schwarzweiß photographiert und die Natur in Farbe. Als es für mich notwendig wurde, etwas Neues zu machen, war der Wechsel zur Farbe nur ein logischer Schritt. Ich habe deswegen meine Vorliebe für die Schwarzweißphotographie nicht verloren, aber ich fühlte mich aufgefordert, Bemer-

DENNIS STOCK ON DENNIS STOCK

Discovery, which is the heartbeat of good photography, occurs more readily when the photographer relinquishes self-consciousness for a state of humility and childlike wonderment. Then, there is a greater freshness and purity in what you capture on film.

To persevere as a photographer, you have to keep moving. Exchanging locations, one for the other, the newness of the subject and your arrogance to believe that you can see it differently are the driving forces. Empathy with the subject plays a major role. Seeking its essence in beauty, suffering and humor is essential to fueling your passion for photographing.

I am not a casual photographer. Themes motivate me to pick up a camera. In principle, it would be more appropriate to refer to me as a photo essayist than a photojournalist. There are many photographers I admire, but the master of them all is W. Eugene Smith. His perseverance in pursuit of the truth deeply influenced my approach to photography. Mostly, I have chosen subjects that have a broad spectrum of visual possibilities and that might enlighten me. I love to spend great lengths of time in search of all the potentials that reveal insights into the subject. It is very hard to decide what theme may have sufficient graphic potential and will keep me in pursuit. I am racking my brain continuously for the next theme.

Being self-competitive is one of my stronger traits. Naturally, there is a certain amount of research for every essay, but mostly it is a question of positioning yourself with the right subject and letting your intuition guide your eye behind the camera. If you sense the potential for a good photograph, you wait, you wait, and you wait. Then, in a fleeting instant, you grasp it like a predator and relish the moment. My essays have served me well as a diary of interesting encounters, often appearing in book form – which is a wonderful permanent remembrance of where I have been.

My subjects – the bikers, hippies, road people, artists – are simply people who have sought a less conforming way to explore this difficult life that we all lead. It was my fascination with their ability to survive as individuals that kept my cameras busy.

Twenty years of chasing people demanded a change in my approach if I was to stay fresh. Since I strongly believe that people are best documented in black-and-white film, and nature in color, when my need arose for something new, a transition to color was logical. It was not a question of losing affection for black and white but of taking up the considerable challenge of making memorable color images by moving on to less activity-driven subjects, and seizing the opportunity to abstract in a painter's style. For me, the subject, not the market, dictates the film to use. I have been equally challenged and gratified in both mediums.

In the past few years, I have concluded that the public's main attraction to the photograph is the need to know about its history. No matter what the style of the photograph, it is essentially informational in character – sometimes about the mood of the

kenswertes auch in Farbe zu veröffentlichen. Ich wandte mich dabei Objekten zu, die weniger aus der Bewegung leben, und versuchte, mehr zu abstrahieren – ähnlich wie ein Maler das tut. Für mich bestimmt das zu photographierende Objekt und nicht der Markt die Wahl des entsprechenden Films. Beide Medien waren eine Herausforderung, die mich befriedigt hat.

In den letzten Jahren bin ich zu der Überzeugung gelangt, daß der Betrachter eines Photos sich hauptsächlich für die Geschichte interessiert, die dahintersteckt. Unabhängig von der Art wie es aufgenommen ist, enthält es eine Reihe wichtiger Informationen: es kann etwas über die Haltung des Photographen als Beteiligtem aussagen, häufiger wird man jedoch etwas über das Objekt, das Thema selbst erfahren.

Ethische Normen stehen immer in direktem Zusammenhang mit gesellschaftlichen Forderungen, und Photographen reflektieren solche Normen. Mit der allenthalben wachsenden Dekadenz unserer Gesellschaften, verschwinden die klaren Visionen früherer Photographen zugunsten einer Ära manipulierter Bilder. Purismus ist nicht mehr gefragt, und eine Konsumhaltung, die ständig Neues fordert, wird jederzeit bedient, um Aufmerksamkeit zu erregen.

Jede Generation verlangt immer noch mehr Reize durch das Bild. Der ständige, fast bewußtlose Umgang mit einer immensen Bilderflut läßt den Betrachter nur noch reagieren, wenn der visuelle Effekt wirklich provokativ anders ist. Das Fernsehen liefert mit seinen bewegten Bildern und dem Ton ein Stimulans, das durch das stehende Bild kaum zu schlagen ist, es sei denn, der Betrachter neigt zum Kontemplativen – in unserer modernen Gesellschaft eher selten der Fall.

Es wird immer einige wenige geben, die das Sanfte einer Leica zu schätzen wissen und so die Welt entdecken; sie werden damit aber in den Medien kaum Beachtung finden. Das Fernsehen ist nun einmal das Medium der Gegenwart und Zukunft, zumindest so lange, bis es durch etwas anderes ersetzt wird.

Für den »Visualisten« ist es von größter Bedeutung, sich einen frischen Blick auf die Dinge zu bewahren. Ich werde mich deshalb in den nächsten Jahren zunehmend mit bewegten Bildern und Ton beschäftigen und halte es für äußerst wahrscheinlich, daß die Videokamera mit ihren Möglichkeiten die Leica der Zukunft sein wird.

Dennis Stock, 1994

photographer as participant, more often about the situation of the subject.

Ethical standards are directly related to societies' demands, and photographers reflect those standards. With the ever-increasing amount of decadence world wide, the clarity of vision of past practitioners is giving way to a time of mostly manipulated images. Purity is less demanded, and consumer newness is the criterion for acquiring attention.

With each generation the picture is obliged to be more stimulating. Our unconscious familiarity with tens of thousands of images makes the viewer respond only when the visual is provocatively new. Naturally, television with its motion and sound gives the observer an initial thrill that can rarely be matched by stills, unless the viewer has a contemplative temperament – which is rare in modern society.

There will always be a small few who use the friendliness of a Leica to explore the world, but their work will find very little receptivity in the media. Television is more appropriate to the present and the future, until something else comes along.

The most important consideration for the "visualist" is to stay fresh. Thus I prefer to explore motion and sound in the coming years, and have high hopes for the potential of the hand-held video camera as the Leica of the future.

Dennis Stock, 1994

»DER PHOTOJOURNALIST«
Die schwarzweißen Jahre

Für alle, die bisher nur Dennis Stocks ausgesprochen poetische Farbphotographien
der Natur kennen, werden die manchmal ergreifenden, manchmal nüchternen
photojournalistischen Schwarzweißaufnahmen des amerikanischen Lebens in die-
sem Buch eine Überraschung sein. Und doch stehen Stocks anscheinend disparate
Kategorien von Arbeiten aufgrund seiner Lebensphilosophie und seiner Entwick-
lung als photographischer Künstler miteinander in Zusammenhang. Stock war im
Photojournalismus so sehr verwurzelt, daß er Andreas Feininger 1951 für dessen
berühmte Photographie »The Photojournalist« Modell stand: Bei dieser Aufnahme
scheint die vertikal gehaltene Leica mit Stocks Gesicht zu verschmelzen, das
Objektiv und der Entfernungsmesser der Kamera werden scheinbar zu seinen
Augen. Aber gerade weil er so oft Chaos und Wahnsinn durch die Linse wahrnahm,
sehnte er sich nach Ordnung und Trost in der Natur.

Dennis Stock wurde 1928 in New York geboren. Sein Vater, ein Maler deutsch-
schweizerischer Abstammung, dessen Arbeiten sein Sohn später – trotz eines guten
graphischen Gespürs des Künstlers – als »mittelmäßig« beurteilte, starb im Jahre
1943. Unzufrieden und allein mit seiner Mutter, einer Engländerin, ging Dennis, weil
er seinen Lebensunterhalt verdienen mußte, ein Jahr später im Alter von sechzehn
zur Navy. Als er kurz nach Kriegsende ausgemustert wurde, war er gezwungen, einen
Beruf zu ergreifen. Er hatte an seine Freunde Schnappschüsse für einen Dollar pro
Stück verkauft und war entschlossen, Photograph zu werden, denn er konnte an
einem Ausbildungsprogramm der Regierung für ehemalige Soldaten teilnehmen und
an der New School studieren. Im Jahre 1946 belegte er einen Kurs bei Berenice
Abbott, stellte jedoch bald fest, daß das Formale des Unterrichts mit seiner Rastlo-
sigkeit schwer zu vereinbaren war und daß Abbotts Vorliebe für sorgfältig gebaute
Kompositionen, die mit einer Großbild-Sucherkamera aufgenommen wurden, wenig
mit seinen Interessen zu tun hatte. Stock wollte unbedingt »Einzelunterricht« und
ständig wechselnde Situationen, die er als Assistent bei einem Photojournalisten zu
finden hoffte. Als er Berenice Abbott nach einem solchen Job fragte, schickte sie ihn
zu Eugene Smith, dem führenden Photoessayisten von »Life«, der ihn einstellte. »Ich
war ein frecher Straßenjunge, der keine Ahnung von Photographie hatte«, erinnert
sich Stock. »Gene brauchte jemand mit Qualifikation.« Obwohl er nur zwei Wochen
als Smiths Assistent arbeitete, sprach Stock später immer wieder von den zutiefst
humanistischen und graphisch starken Essays des älteren Kollegen, die entscheiden-
den Einfluß auf seine eigene Arbeit gehabt hätten.

Ebenso wichtig war ein freundlicher Rat, den Stock von Smith zum Abschied bekam:
»Du solltest für einen gewissen Gjon Mili arbeiten; der wird dich wirklich auf Trab
bringen.« Mili, ein Albaner, den Jean-Paul Sartre als Kreuzung zwischen Ameisen-
bär und montenegrinischem Banditen beschrieb, war ein führender Photograph bei

"THE PHOTOJOURNALIST"
The Black and white Years

To anyone who knew only Dennis Stock's exquisitely poetic color photographs of nature, the sometimes poignant, sometimes wry black-and-white photojournalistic images of American life in this book would come as a surprise. And yet Stock's two seemingly disparate bodies of work are integrally related in his philosophy of life and in his evolution as a photographic artist. Stock's roots in photojournalism were so deep that it was he who, in 1951, posed for Andreas Feininger's famous photograph entitled "The Photojournalist", in which a vertically-held Leica seems to merge with Stock's face, the camera's lens and viewfinder seeming to become his eyes. But it was precisely the chaos and the madness he so often saw through his rangefinder that led him to seek order and solace in nature.

Dennis Stock was born in New York City in 1928. His father, a German-Swiss painter whose work his son would later judge as "mediocre" despite the artist's good graphic sense, died in 1943. Unhappy at home with his British-born mother, and faced with the need to earn a living, Dennis joined the Navy as soon as he turned sixteen the following year. When he was mustered out shortly after the end of the war, he had to choose a career. Having sold snapshots to friends for a dollar apiece, he settled on photography and took advantage of the G. I. Bill to study at the New School. In 1946 he took a course there with Berenice Abbott, but he found that the formality of the classroom didn't suit his restless temperament, and her emphasis on meticulous compositions shot with a large-format view camera was not in keeping with his interests. Stock decided that what he needed was the one-on-one training and the constant variety of situations that working as a photojournalist's assistant would offer. When he asked Abbott about finding such a job, she sent him to Eugene Smith, the dean of "Life" photo-essayists, who hired him. "I was this brassy kid off the street, who knew nothing about photography," Stock later recalled. "Gene needed somebody with real qualifications." Although he lasted only two weeks as Smith's assistant, Stock would always cite the older man's profoundly humanistic and graphically powerful essays as an important influence on his own work.

Equally important was a bit of kindly advice that Smith gave Stock as he was leaving: "You ought to work for a guy named Gjon Mili; he'll really kick your ass around." Mili, an Albanian whom Jean-Paul Sartre described as looking like a cross between an anteater and a Montenegrin bandit, was a leading photographer for both "Life" and "Vogue." Having studied electrical engineering at the Massachusetts Institute of Technology with Harold Edgerton, who had perfected the stroboscopic flash, Mili made specialties of photographs that show an action at the microsecond of peak intensity and multiple-exposure images showing the flow of motion. Editors sent a dazzling galaxy of dancers, classical and jazz musicians, actors and actresses, fashion models, and athletes to Mili's studio, in a huge loft on East Twenty-third

»Life« und »Vogue«. Nach seinem Studium der Elektrotechnik am Massachusetts Institute of Technology bei Harold Edgerton, der den Stroboskop-Blitz perfektioniert hatte, wurde Mili ein Spezialist für Photographien, auf denen ein Vorgang in der Mikrosekunde der größten Intensität erfaßt wird, und von mehrfach belichteten Aufnahmen, die einen Bewegungsfluß abbilden. Die Herausgeber der Zeitschriften schickten Scharen von Tänzern, Musikern der klassischen Musik und des Jazz, Schauspielern und Schauspielerinnen, Models und Sportlern für Bewegungsstudien und Portraitaufnahmen in Milis Atelier, das sich in einem großen Loft in der East Twenty-third Street in New York befand. Mili war ein sympathischer und geselliger Mann. Viele seiner Modelle wurden zu Freunden, die abends zu Parties, Pokerrunden und Jamsessions in seinem Atelier erschienen. Zu Milis berühmtesten Freunden gehörte Robert Capa; zusammen photographierten die beiden im Sommer 1949 Picasso an der Riviera.

Nachdem er eine Zeitlang als freiberuflicher Assistent für verschiedene Photographen gearbeitet hatte, wurde Stock schließlich als Milis Faktotum fest angestellt. »Ich arbeitete vier Jahre lang für Mili: vier Jahre eine richtige Lehre nach europäischem Vorbild, für fünfundzwanzig Dollar die Woche.« Am Anfang fegte er den Boden von Milis Atelier und trug die schwere Ausrüstung, wenn Außenaufnahmen gemacht wurden. Nach und nach betraute Mili ihn nicht nur damit, beim Arrangieren der Aufnahmen zu helfen, sondern auch mit dem Entwickeln und Vergrößern der Bilder. Durch diese Arbeit mit Mili, bei der er manchmal bis drei Uhr morgens in der Dunkelkammer stand, lernte Stock sehr schnell. Mili, trotz seiner bohèmehaften Erscheinung ein disziplinierter Perfektionist, war seinem Lehrling gegenüber – für den das Atelier seines Mentors die Universität war – »sehr anspruchsvoll, aber auch sehr großzügig«.

Im Frühjahr 1951 schrieb »Life« einen Wettbewerb für amerikanische Photographen bis einunddreißig aus, die bereits irgendwo mindestens ein Photo veröffentlicht hatten. Der Wettbewerb gliederte sich in zwei Bereiche: einen für Photoessays und einen für Einzelaufnahmen. Stock war vor allem am Essay interessiert und wartete monatelang auf eine Story, die er photographisch dokumentieren konnte. »Es ging darum, ein Thema zu finden, das graphisch stark und zutiefst menschlich war,« erinnert sich Stock. Eines Tages im August begleitete er einen Freund, der den Auftrag hatte, die Ankunft eines Schiffs mit Deutschen und Polen, auf der Flucht vor dem Kommunismus, am Pier der United States Lines in Manhattan zu photographieren. Stock war sofort klar, daß er seine Story gefunden hatte; er machte drei Tage lang Aufnahmen mit einer 35mm-Kamera und einer Rolleiflex. In den Gesichtern der entwurzelten Menschen zeigte er Angst, Verwirrung, Sorge und Hoffnung.

Bei der aus sieben Männern bestehenden Jury, die die Arbeiten der 1730 Wettbewerbsteilnehmer bewertete, hatten Edward Steichen, damals Direktor der photographischen Abteilung des Museum of Modern Art, und Roy Stryker den Vorsitz. Stryker leitete das Photoarchiv der Farm Security Administration, für das Walker Evans, Dorothea Lange und viele andere arbeiteten. In der Ausgabe von »Life« vom

Street, for both motion studies and portraits. Mili was such a likeable and gregarious man that many of his subjects became friends who returned to his studio after hours for parties, poker games, and jam sessions. Among Mili's celebrated friends was Robert Capa; together they would photograph Picasso on the Riviera during the summer of 1949.

After a period of working as a freelance assistant for many photographers, Stock ended up with a full-time job as Mili's factotum. "I worked for Mili for four years; four years of real apprenticeship, European style, twenty-five dollars a week," Stock has recalled. He began by sweeping the floors of Mili's studio and carrying heavy equipment when Mili went out on assignments. Gradually Mili entrusted him not only with helping to set up shots but also with developing and printing. Working at Mili's side, and sometimes printing until three in the morning, Stock learned quickly. Mili, who despite his bohemian appearance was a disciplined perfectionist, was "very demanding but very generous" to his apprentice, who remembers his mentor's studio as his university.

In the spring of 1951 "Life" announced a contest for American photographers under the age of thirty-one who had already had at least one picture published somewhere. The contest had two divisions, one for picture stories and one for individual pictures. Stock was primarily interested in the former and worried for months about coming up with a story to shoot. "The problem was to find a subject that was graphically strong and deeply human," he recalls. One day in August he accompanied a friend who had an assignment to photograph the arrival of a shipload of German and Polish refugees from Communism at the pier of the United States Lines in Manhattan. Stock immediately realized that he had found his story and spent three days shooting with a 35-mm camera and a Rolleiflex. In the faces of these uprooted people he caught expressions of fear, confusion, grief, and hope.

The panel of seven men who judged the entries sent in by 1,730 photographers was headed by Edward Steichen, at that time director of the photography department of the Museum of Modern Art, and by Roy Stryker, who had administered the photographic unit of the Farm Security Administration, for which Walker Evans, Dorothea Lange and many others worked. The issue of "Life" dated November 26, 1951, announced Dennis Stock as the winner of the $3,000 first prize in the Picture Story Division of its contest, and a two-page spread was devoted to his winning story. The photograph given greatest prominence was the one reproduced first in the present book – a baby of hauntingly penetrating and thoughtful gaze, a face whose expression reflects an extraordinary precocity of both sadness and fortitude. A timeless symbol of the American immigrant experience, she could easily be a little Pilgrim landing at Plymouth Rock.

As a result of the prize, 23-year-old Stock was approached by Robert Capa, who was famous for his heroic and compassionate coverage of the Spanish Civil War and the European theater of World War II. Capa invited Stock to become an associate member of Magnum, the photographers' cooperative agency founded in 1947 by Capa and

26. November 1951 wurde Dennis Stock als Gewinner des mit 3000 Dollar dotierten Preises für den Bereich Photoessay bekanntgegeben, und über die Geschichte des Gewinners wurde auf einer Doppelseite berichtet. Eine Aufnahme – übrigens die erste im vorliegenden Buch – fand besondere Beachtung: ein Baby mit durchdringendem, nachdenklichem Blick; ein Gesicht, mit einem fast frühreifen Ausdruck von Trauer und Stärke. Als zeitloses Symbol für die Erfahrungen der Emigranten in Amerika könnte das kleine Mädchen auch zu einer Familie der Pilgrim Fathers gehören, die gerade in Plymouth Rock gelandet sind.

Nachdem Stock den Preis gewonnen hatte, trat Robert Capa, der sich mit seinen heroischen und leidenschaftlichen Berichterstattungen über den Spanischen Bürgerkrieg und die Schauplätze des Zweiten Weltkriegs einen Namen gemacht hatte, an ihn heran. Capa schlug dem 23jährigen vor, außerordentliches Mitglied von Magnum zu werden, einer Photographenagentur, die 1947 von Capa und seinen Freunden David Seymour (bekannt als »Chim«), Henri Cartier-Bresson, George Rodger und William Vandivert gegründet worden war. Die Agentur war eine Art Elite-Club, dessen feste Mitglieder ausschließlich herausragende und anerkannte Photojournalisten waren. Aber Magnum suchte auch stets nach neuen, förderungswürdigen Talenten. Vielversprechende junge Photographen wurden als außerordentliche Mitglieder, als Freiberufler, aufgenommen, deren Arbeiten die Agentur unter Einbehaltung eines bestimmten Prozentsatzes vertrieb. Capa, der mit seiner Dokumentation des Spanischen Bürgerkriegs im Alter von 23 Jahren begonnen hatte, nahm sich besonders gern der außerordentlichen Mitglieder an. Er verschaffte ihnen Aufträge, gab ihnen Ratschläge, kritisierte sie, lieh ihnen Geld und lud sie zum Essen ein. Die Hälfte seiner Arbeitszeit verbrachte er in Paris, dem Hauptsitz von Magnum, die andere in der New Yorker Filiale und entdeckte etwa zehn junge Europäer und Amerikaner, die schließlich zu festen Mitgliedern wurden. Darunter waren auch Dennis Stock und Elliott Erwitt, der den zweiten Preis des Wettbewerbs von »Life« gewonnen hatte.

Capa war mit Sicherheit besonders am Thema des prämierten Photoessays von Stock interessiert. Wegen seiner linksgerichteten politischen Aktivitäten im Alter von siebzehn Jahren aus seinem Heimatland Ungarn ausgewiesen, mußte Capa 1933 zuerst aus Berlin und 1939 aus Paris fliehen. Er wußte aus eigener Erfahrung, was es heißt, ein Flüchtling zu sein und hatte in Spanien, China und während des Zweiten Weltkriegs in ganz Europa Menschen auf der Flucht photographiert. In den Jahren 1949 und 1950 hatte er die Ankunft von Flüchtlingen in Israel gefilmt und photographiert. Stocks wie Capas Aufnahmen von Flüchtlingen bringen menschliche Wärme und Anteilnahme zum Ausdruck.

Obwohl Magnum für höchsten Standard im Photojournalismus stand, war etliches, was der Großteil der festen und außerordentlichen Mitglieder machte, ausgesprochen kommerziell. Capa war sehr daran gelegen, daß alle Magnum-Photographen ein gesichertes Einkommen hatten, denn sie sollten unabhängig genug sein, auch nicht-kommerzielle Arbeiten zu verwirklichen. So führte Stock der erste Magnum-Auftrag

his friends David Seymour (known as "Chim"), Henri Cartier-Bresson, George Rodger, and William Vandivert. The agency was a kind of elite club in which full membership was limited to outstanding photojournalists with established careers. But Magnum were always looking for new talent to develop. Promising young photographers were taken on as associate members, freelancers whose work the agency would handle for a percentage. Capa, who had begun his coverage of the Spanish Civil War when he was twenty-three, took a particular interest in the associates. He got them assignments, gave them advice and criticism, lent them money, and took them out to dinner. Dividing his time between Magnum's main office in Paris and its branch office in New York, he recruited about ten young Europeans and Americans who would eventually become full members. Among them were Dennis Stock and Elliott Erwitt, who had won the second prize in the "Life" contest.

Capa was certainly drawn to the subject matter of Stock's winning photo-essay. Exiled from his native Hungary at the age of seventeen because of his leftist activities, Capa subsequently had to flee Berlin in 1933 and Paris in 1939. He knew a thing or two about being a refugee himself and had photographed refugees in Spain, China, and throughout Europe during World War II. In 1949 and 1950 he had photographed and filmed refugees arriving in Israel. Stock's photographs of refugees are distinguished by a human warmth and sympathy in keeping with Capa's own.

Although Magnum stood for the highest standards of photojournalism, some of the work done by most of the members and associates was forthrightly commercial. Capa was very concerned with seeing that all the Magnum photographers made a good living so that they would have the freedom to pursue their work on non-commercial subjects. And so it was that Stock's first Magnum assigment took him to Alaska to do a story for General Motors about a schoolbus getting through under harsh conditions.

Paris was Mecca for the young Magnum photographers. It was there that one might meet the legendary Cartier-Bresson, whom Dennis Stock greatly admires. The Frenchman had started out as a Surrealist painter and had perfected the art of capturing what he called the "decisive moment," at which an action or an emotion peaked or in which surreal juxtapositions fell into place. It was also in Paris that Capa might take one to the Ritz for a drink with Ernest Hemingway or to the races for an afternoon with John Huston. There, too, one encountered Magnum photographers returning from assignments all over the world.

In 1952 Stock visited Paris for the first time, making his way there via Ethiopia, where he photographed a week in the life of Emperor Haile Selassie. In Paris, Capa suggested that Stock – who would soon become a full member – should be the Magnum photographer in Hollywood. Capa was himself very involved with the movies. Right after the war he had spent about six months in Hollywood where he had hoped to become a director and where he had photographed Ingrid Bergman – with whom he was then having a romance – in her films "Notorious" and "Arch of Triumph." Hating the phoniness of Hollywood, Capa had soon left; but he continued to view the

nach Alaska, wo er für General Motors über die Fahrten eines Schulbusses bei extremen Witterungsverhältnissen berichten sollte.

Das Mekka der jungen Magnum-Photographen war Paris, denn hier konnte man vielleicht den legendären Cartier-Bresson treffen, den Dennis Stock sehr bewundert. Der Franzose hatte als surrealistischer Maler begonnen und etwas perfektioniert, das er die Kunst des »entscheidenden Moments« nannte: die Wahrnehmung des Augenblicks, in dem eine Handlung oder Emotion ihren Höhepunkt erreicht oder in dem sich surreale Kontraste ergeben. In Paris konnte es einem auch passieren, daß man von Capa auf einen Drink mit Ernest Hemingway ins Ritz oder zu einem Pferderennen in Gesellschaft von John Huston eingeladen wurde. Und hier traf man auch Magnum-Photographen, die von ihren Aufträgen in aller Welt zurückkehrten.

Stock besuchte Paris zum erstenmal 1952 nach einem Auftrag in Äthiopien, wo er eine Woche im Leben von Kaiser Haile Selassi dokumentiert hatte. In Paris schlug Capa vor, daß Stock, der bald als festes Mitglied dabei sein würde, Magnum-Photograph in Hollywood werden solle. Capa selbst hatte eine enge Beziehung zum Film. Unmittelbar nach Kriegsende war er, in der Hoffnung Regisseur zu werden, ungefähr ein halbes Jahr nach Hollywood gegangen. Während der Dreharbeiten zu »Notorious« und »Arch of Triumph« photographierte er dort Ingrid Bergmann, mit der er auch eine Affäre begann. Da er die Oberflächlichkeiten Hollywoods haßte, verließ Capa Los Angeles bald wieder, betrachtete die Filmindustrie aber weiterhin als potentielle Geldquelle für Magnum und machte Produktions- und Standphotos in einer Reihe von Filmen, die in Europa gedreht wurden.

Dennis Stock hatte Filme schon immer geliebt. Während seiner bedrückenden Kindheit fieberte er stets den Samstags-Matineen des Kinos im Nachbarort entgegen, die ihn seinen Kummer für eine Weile vergessen ließen. Bereitwillig floh er in die magische Welt der großen Leinwand, in der alles möglich schien. Seine Arbeit in Hollywood begann er jedoch mit gemischten Gefühlen. Da er als Photojournalist den Dingen auf den Grund gehen wollte, fühlte er sich nun in einer Zwickmühle, weil dort in erster Linie Oberflächlichkeit gefragt war.

Bei seinem ersten großen Auftrag sollte er den Film »The Caine Mutiny« dokumentieren. Hauptdarsteller Humphrey Bogart war der junge Photograph sofort sehr sympathisch. Die Reputation von Magnum, gute Beziehungen zu »Life« und die Verbindungen, die Bogart mit Stars, Agenten, Regisseuren und Aufnahmeleitern für ihn herstellte, waren ausgezeichnete Voraussetzungen für seine Karriere in Hollywood. Er erhielt mühelos Aufträge und Angebote für exklusive Berichterstattungen. Problematisch war allerdings, daß er in seinen Portraits der Stars mehr zeigen wollte als das bekannte Gesicht: das Wesen der Person hinter der öffentlichen Maske sollte zum Vorschein kommen – sehr zum Mißbehagen der Macher in Hollywood. In seinen Produktionsaufnahmen ging es Stock darum, die »entscheidenden Momente« des Dramas oder der Interaktionen hinter der Kamera einzufangen und nicht das Gesicht eines Stars im attraktivsten Licht zu präsentieren. Da die New Yorker Herausgeber seine Arbeit schätzten, erhielt Stock viele Aufträge und

movie industry as a potential cash-cow for Magnum and made production shots and publicity stills of a number of movies being shot on location in Europe.

Dennis Stock had always loved the movies. As an unhappy child he had counted on Saturday matinees at his neighborhood theater to help him forget his troubles for a while. Eagerly he would escape into the magical world on the large screen where everything seemed possible. But it was with mixed feelings that he settled in Hollywood. Aspiring to be a penetrating photojournalist, he found himself trapped in a place where the ruling powers demanded superficiality.

His first big assignment was to cover "The Caine Mutiny," starring Humphrey Bogart, who took a liking to the young photographer. With the cachet of Magnum, good relations with "Life," and Bogart's introductions to stars, agents, directors, and studio executives, Stock's career in Hollywood was launched. He had no trouble getting assignments and guarantees of exclusive coverage. The problem was that in his portraits of stars he wanted to do more than simply show a famous face; he wanted to reveal the essence of the person beneath the public mask – and that made the studios uncomfortable. In his production shots he strove to catch the "decisive moments" of the drama or of off-camera interactions rather than to record those moments when the star's face was turned to the most flattering angle. Since the New York editors liked his work, Stock was kept very busy photographing the production of such movies as "Sabrina" (1954), "Guys and Dolls" (1955), "Oklahoma" (1955), "The Blackboard Jungle" (1955), and "Bus Stop" (1956). It was with great relief that he could turn to an occasional story about a person whom he admired, such as Adlai Stevenson, Alexander Calder, or Igor Stravinsky.

Stock's best friends in Hollywood were mostly homesick New Yorkers like himself. One was director Nicholas Ray, who had made such films as "They Live by Night" and "Johnny Guitar." At one of his Sunday-afternoon gatherings in 1954 Ray introduced Stock to a young actor named James Dean, who was to star in Ray's next film, "Rebel Without a Cause." Dean's first starring role was in the soon-to-be-released "East of Eden," directed by Elia Kazan, whose previous film, "On the Waterfront," had recently made a sweep of the Academy Awards. Dean, who played an anguished son who could never please his Calvinistic father, was clearly hoping to step into the shoes of Marlon Brando, who had won the award for best actor. When Stock went to a preview of "East of Eden" he was overwhelmed by Dean's performance and proposed doing a photo-essay about the rising star for "Life," whose editors approved the idea.

In February 1955 Stock and Dean traveled to Fairmount, Indiana, where the actor had been raised by an aunt and uncle on their farm. In the course of a week there, Stock made a number of photographs that have become not only the classic images of Dean but also classics of American portraiture. Although the photo with a sow (ill. p. 71) is a playful parody of naive American portraits, it and the other barnyard pictures suggest the essence of Dean's childhood when his artistic yearnings must have made him feel closer to the accepting animals than to his family and neighbors.

photographierte bei Dreharbeiten zu Filmen wie »Sabrina« (1954), »Guys and Dolls« (1955), »Oklahoma« (1955), »The Blackboard Jungle« (1955) und »Bus Stop« (1956). Er war außerordentlich erfreut und erleichtert, wenn er von Zeit zu Zeit eine Story über jemand machen konnte, den er bewunderte, wie Adlai Stevenson, Alexander Calder oder Igor Strawinski.

Stocks beste Freunde in Hollywood waren überwiegend heimwehkranke New Yorker (wie er selbst auch), unter ihnen Regisseur Nicholas Ray, der Filme wie »They Live by Night« und »Johnny Guitar« gemacht hatte. Im Jahre 1954 – bei einem seiner samstäglichen Zusammenkünfte – stellte Nicholas Ray seinen Freund Stock dem jungen James Dean vor, Star in »Rebel Without a Cause«, Rays nächstem Film. Seine erste Hauptrolle hatte Dean in dem kurze Zeit später erscheinenden Film »East of Eden« unter der Regie von Elia Kazan, dessen letzter Film »On the Waterfront« jede Menge Oscars bekommen hatte. Dean, der es in seiner Rolle als ständig zürnender Sohn seinem kalvinistischen Vater nie recht machen kann, hoffte, in die Fußstapfen Marlon Brandos zu treten, der den Oscar für die beste Hauptrolle bekommen hatte. Als Stock eine Pressevorführung von »East of Eden« besuchte, war er von Deans schauspielerischer Leistung überwältigt und schlug dem Herausgeber von »Life« vor, ein Photoessay über den aufsteigenden Star zu machen.

Im Februar 1955 fuhren Stock und Dean nach Fairmount, Indiana, wo der Schauspieler auf der Farm seines Onkels und seiner Tante aufgewachsen war. Sie verbrachten dort eine Woche, und Stock machte eine Reihe von Photographien, die nicht nur zu *den* klassischen Bildern von Dean, sondern auch zu Klassikern der amerikanischen Portraitphotographie geworden sind.

Obwohl das Photo mit der Sau (Abb. S. 71) nur eine spielerische Parodie auf naive amerikanische Portraits ist, scheinen diese und die anderen auf der Farm entstandenen Aufnahmen Wesentliches aus Deans Kindheit zu vermitteln. Er muß sich mit seinen künstlerischen Neigungen den duldsamen Tieren näher gefühlt haben als seiner Familie oder seinen Nachbarn. Die Aufnahmen Stocks zeigen die Kluft zwischen Dean und der Erwachsenenwelt, die später seine enorme Anziehungskraft ausmachte. Der Ausbruch aus solchen Verhältnissen und sein kometenhafter Aufstieg beflügelten bei allen Teenagern – männlich oder weiblich – die typische Cinderella-Phantasie: mißverstanden und völlig unterschätzt, aber mit außergewöhnlicher Begabung, die es zu entdecken gilt, wird man, von einem Prinz oder einer Prinzessin geliebt, endlich zum Star.

Dennis Stock, der nur drei Jahre älter war als Dean, wurde ein guter Freund des Schauspielers. In ihrem Empfinden recht ähnlich, haßten sie beide die knallhart kommerzielle Seite Hollywoods, schafften es aber, sich dort ohne Kompromisse durchzusetzen. Ihre Freundschaft wird in den Aufnahmen spürbar, und beide hatten offensichtlich an dieser Zusammenarbeit Spaß. Sogar bei Photos, auf denen Dean völlig selbstvergessen erscheint, spürt man, daß er sich der Gegenwart Stocks und seiner Kamera durchaus bewußt war. Er spielte *immer:* das war der Kern seines Erfolgs und seiner Tragödie. Stocks Photos von Dean, dessen Ruhm die Filme

The photographs depict the roots of the alienation from the adult world that was the key to Dean's enormous appeal. His progress from such origins to instant stardom played into every male and female teenager's Cinderella fantasy of being a misunderstood and unappreciated person of extraordinary potential waiting to be recognized, to be loved by a prince or princess, and to become a star.

Dennis Stock, who was only three years older than Dean, became a good friend of the actor. Of similar temperament, they both hated the crass commercialism of Hollywood but managed to thrive there without compromise. Their friendship is evident in the photographs, for they obviously had fun collaborating on them. Even when Dean appears least self-conscious, one senses that he was nevertheless aware of Stock and his camera. He was always performing – and that fact was at heart of both his success and his tragedy. In effect, Stock's photographs of Dean – whose reputation rests on his performances in "East of Eden," "Rebel Without a Cause," and "Giants" – add up to the actor's fourth great film.

Stock was deeply shaken by Dean's death in an automobile crash in September 1955 and went to Indiana for the funeral. As a result of the Dean cult that arose almost immediately, Stock's photographs of the actor began to be in great and steady demand. In effect, Dean's legacy to Stock would be a measure of financial independence that would allow him to pursue the work that really interested him, though he would still shoot his share of photographs for annual reports. When "Look" sent Stock to Japan with Ed Sullivan for two weeks in May 1956, the photographer discovered a new world and a new way of looking at his old world. Overwhelmed by the beauty of the Japanese way of life, he ended up staying a year and traveled all over the country. "Japanese art, both classical and modern, corresponds to my temperament," Stock has written. He felt that in Japan he was really discovering himself.

He proceeded to travel widely in the Far East, and spent five weeks in a Buddhist monastery in Thailand. When he got back to his hotel and saw the newspapers for the first time in weeks, he read about the Hungarian revolution and the Suez crisis – and went right back to the monastery. There he found a kind of equilibrium that related to what he has called his "perpetual search for order."

When Stock returned to America, New York became his base of operations and he embarked on one of his most important and satisfying projects, an ambitious documentation of the world of jazz. When he was a child, Stock's family had lived in upper Manhattan, close to Harlem. On many a Sunday, Dennis accompanied his father to hear the greats of jazz perform at Harlem's famous Apollo Theater. Now, in 1957, the young photographer set out not only to make portraits of all the outstanding jazz musicians then playing but also to make images that would be visual equivalents to the improvisational music. That effect is reinforced by the layout that Stock designed for the resulting book, "Jazz Street," with text by jazz critic Nat Hentoff. After a brief section in which the photographs show the roots of jazz in New Orleans bands, the blues, and gospel, followed by a chapter mostly about Louis Armstrong's life on the road, the main part of the book concentrates on the

»East of Eden«, »Rebel Without a Cause« und »Giants« begründeten, könnten als der vierte große Film des Schauspielers gedeutet werden.

Stock war erschüttert, als er im September 1955 erfuhr, daß Dean bei einem Autounfall ums Leben gekommen war, und fuhr zur Beerdigung nach Indiana. Der Dean-Kult, der fast unmittelbar nach seinem Tod einsetzte, ließ das Interesse an Stocks Aufnahmen sprunghaft steigen. Deans Vermächtnis an Stock war also eine gewisse finanzielle Unabhängigkeit, die es ihm erlaubte, sich Arbeiten zu widmen, die ihn wirklich interessierten, auch wenn er noch immer sein Kontingent an Photos für die Jahresberichte lieferte.

Als die Zeitschrift »Look« Stock zusammen mit Ed Sullivan im Mai 1956 für zwei Wochen nach Japan schickte, entdeckte der Photograph eine neue Welt und eine neue Sicht auf die alte, ihm bekannte. Hingerissen von der Schönheit des japanischen Lebens, blieb er schließlich ein Jahr und bereiste das ganze Land. »Die japanische Kunst – modern oder klassisch – entspricht meiner Natur«, schrieb Stock. Er hatte das Gefühl, in Japan sich selbst zu entdecken.

Er reiste weiter in den Fernen Osten und verbrachte fünf Wochen in einem buddhistischen Kloster in Thailand. Als er in sein Hotel zurückkehrte und nach Wochen zum erstenmal wieder eine Zeitung in die Hand nahm, berichtete man gerade über die ungarische Revolution und die Suez-Krise: er machte sich sofort wieder auf den Weg ins Kloster. Dort fand er zu einem inneren Gleichgewicht, das seiner »ständigen Suche nach Ordnung« entsprach.

Nach seiner Rückkehr in die Vereinigten Staaten wurde New York zum Ausgangspunkt seiner Aktivitäten. Er begann mit einem seiner wichtigsten und erfüllendsten Projekte, einer ambitionierten Dokumentation über die Welt des Jazz. Als er noch ein Kind war, hatte Stocks Familie in Upper Manhattan, in der Nähe von Harlem gelebt. An etlichen Sonntagen hatte Dennis seinen Vater ins berühmte Harlemer Apollo Theater begleitet, um die Großen des Jazz zu hören. 1957 nun wollte der junge Photograph nicht nur alle berühmten Jazzmusiker portraitieren, sondern auch Aufnahmen machen, die das Improvisierte der Musik bildlich werden ließen. Diesen Ansatz betonte Stock durch das Layout, das er für sein Buch »Jazz Street« entwarf, zu dem der Jazzkritiker Nat Hentoff den Text schrieb. Auf einen kurzen Abschnitt mit Photos, die die Wurzeln des Jazz in den Bands, dem Blues und den Gospels von New Orleans zeigen, folgt eine Sequenz zu Louis Armstrong »auf Tour«. Schwerpunkt im Hauptteil des Buchs sind Aufnahmen, die vor allem Gesichter und Hände der Musiker betonen. Die Photos, reproduziert in unterschiedlichen Größen, mit weißem oder schwarzem Hintergrund, manche zum extremen Hochformat beschnitten oder als Folge wie Filmstreifen montiert, lassen in ihrem Verlauf einen komplexen Rhythmus von bildlichen Ensemble- und Soloparts entstehen.

Mit »Jazz Street« verfolgte Stock seine Auseinandersetzung mit dem Phänomen der Entfremdung in Amerika weiter, allerdings eher humorvoll als verbissen oder bitter. Diese Welt war so weit vom Alltäglichen entfernt, daß die Nacht zum Tag wurde. Dafür herrschten hier Lebensfülle, Ausdruckskraft, Kameradschaft und ein tiefes

faces and hands of musicians. There the images reproduced large or small, against white or black backgrounds, a few cropped to a long and narrow format, others in filmstrip-like sequences, create a complex rhythm of ensembles and solos.

"Jazz Street" continued Stock's exploration of alienation in America, but in a joyous rather than a bitter mode. Here was a world so removed from the ordinary that day and night were reversed, but within that world were exuberance, verve, camaraderie, and the deep rapport of collaboration. This was also, as Stock's photographs emphasize, an integrated world in which black and white Americans made fabulous music together. It was as recently as 1956 that a boycott led by Dr. Martin Luther King, Jr., had brought about the desegregation of buses in Montgomery, Alabama, and the following year federal troops had to be sent to Little Rock, Arkansas, to enforce the law ending segregation in public schools.

During the late 1950s and the first two years of the 1960s, Stock was casting around for a new direction even while he turned again to the movie production shots for income. He was one of the half-dozen Magnum photographers to cover the shooting of John Huston's film "The Misfits," and he photographed John Wayne in "The Alamo" and an all-star cast in "Long Day's Journey into Night." He also experimented with working as a film-dialogue coach, as a second-unit director, and as a television producer. But he felt he wasn't really going anywhere.

Stock was increasingly plagued by a sense of the emptiness and futility of American life. He was depressed by the prevalent materialism and the frantic scramble for financial success that struck him as collective madness. In 1962, when he got married and moved to semi-rural Pound Ridge, fifty miles northeast of New York City, his life was revolutionized by the discovery that the beauty of nature restored his soul.

Immersing himself in nature calmed his shattered nerves and broke through his creative block. He found, as he has written, that contact with nature could give him "the strength to look squarely at what is bad and to deal with it in a constructive way."

He soon began to photograph details of nature in color. He had always used black-and-white film to photograph people, cutting through the distraction of color to a kind of X-ray image of form, character, and emotion. But color is obviously an integral part of nature's beauty. For inspiration in using color film Stock turned to his Magnum friend Ernst Haas, whose daringly original impressionistic color studies of New York City had been published in "Life" in 1953 and were exhibited at the Museum of Modern Art in 1962. While Haas continued to focus primarily on urban subjects, Stock now developed a related vision of nature. Conceiving his photos of nature as candid shots, not still lifes, Stock has always insisted that they also owe much to Mili's training in arresting the flow of motion, for flowers and grasses are constantly moving in the breeze and the light is constantly changing. Eliot Porter had, of course, been making color photographs of nature since the late 1930s. But while Porter approached nature as a scientist, whose images nevertheless have an undeniable poetry, Stock approached nature as a lyric poet and mystic.

Confirmation of that direction came while Stock was on assignment in Italy to pho-

Gefühl der Zusammengehörigkeit. Stocks Photographien machen deutlich, daß diese Welt auch ein Ort der Begegnung war, wo schwarze und weiße Amerikaner zusammen hinreißende Musik machten. Erst 1956 hatte ein von Martin Luther King initiierter Boykott dazu geführt, daß die Rassentrennung in Montgomery, Alabama, aufgehoben wurde. Im folgenden Jahr mußten Truppen der Bundesarmee nach Little Rock in Arkansas entsandt werden, um das neue Gesetz zur Abschaffung der Rassentrennung in öffentlichen Schulen durchzusetzen.

Ab Ende der fünfziger Jahre bis 1962 war Stock auf der Suche nach einer neuen Richtung, machte aber gleichzeitig Aufnahmen von Filmproduktionen, um seinen Lebensunterhalt zu verdienen. Er war einer der sechs Magnum-Photographen, die die Dreharbeiten zu John Hustons Film »The Misfits« dokumentierten, und er photographierte John Wayne bei »The Alamo« und in dem mit vielen Stars besetzten Film »Long Day's Journey into Night«. Er versuchte sich auch als Dialogregisseur, Regieassistent und Fernsehproduzent. Aber all das brachte ihn nicht weiter.

Stock litt zunehmend unter der Leere und Nutzlosigkeit des amerikanischen Lebensstils. Das überbetonte materialistische Denken und die besessene Jagd nach wirtschaftlichem Erfolg deprimierten ihn: er empfand das als kollektiven Wahn. Als er 1962 heiratete und in die ländliche Gegend von Pound Ridge, 50 Meilen nordöstlich von New York zog, veränderte sich sein Leben total, weil er spürte, daß er in der Schönheit der Natur Frieden fand. Die Natur beruhigte seine überreizten Nerven und löste seine kreativen Blockaden. Er stellte fest, so schrieb er, daß das Leben in der Natur ihm »Kraft gab, sich dem Negativen zu stellen und auf konstruktive Weise damit umzugehen«.

Er begann nun, farbige Detailaufnahmen der Natur zu machen. Menschen hatte er immer nur in Schwarzweiß photographiert; ohne Ablenkung durch die Farbe sollte so eine Art Röntgenbild aus Gestalt, Charakter und Gefühlsausdruck entstehen. Farbe ist allerdings ein wesentliches Element der Natur in ihrer Schönheit. Er wandte sich an seinen Magnum-Kollegen Ernst Haas, um sich Anregungen für den Umgang mit der Farbphotographie zu holen. Dessen äußerst eigenwillige impressionistische New-York-Studien wurden 1953 in »Life« veröffentlicht und 1962 im Museum of Modern Art ausgestellt. Während Haas sich weiterhin in erster Linie auf urbane Themen konzentrierte, entwickelte Stock nun eine ähnliche Sicht auf die Natur. Stock bildete die Natur auf seinen Photos unmittelbar und direkt ab, nicht als Stillleben, und betonte immer wieder, daß der Einfluß Milis darin sehr deutlich zum Ausdruck komme, bei dem er gelernt hatte, den Fluß einer Bewegung einzufangen. Blumen und Gräser bewegen sich ja im Wind, und auch das Licht verändert sich ständig. Auch Eliot Porter hatte – bereits seit Ende der dreißiger Jahre – Farbphotos von der Natur gemacht. Doch während sich Porter der Natur als Wissenschaftler näherte, auch wenn seine Bilder durchaus Poesie haben, begegnete Stock ihr als wahrer Poet und Mystiker.

Eine Bestätigung für diesen Ansatz erhielt Stock, als er sich wegen eines Auftrags, die Welt des Franz von Assisi zu photographieren, in Italien aufhielt. Inspiriert durch

tograph the world of St. Francis of Assisi. Reading the saint's writings, and inspired by the Umbrian landscape, Stock had an epiphany. He would begin a more-than-ten-year, around-the-world project of photographing what St. Francis called "Brother Sun" as the universal creative force. He would not photograph the sun directly, but he would capture its light around the edges of natural forms, record its reflections, and use glimmers, rays, and shadows as graphic elements. At the same time, he would work on a separate but profoundly related series about the cycle of the seasons. How can people be so negative, asked Stock, when in Nature the spring and its glories always follow even the hardest winter?

Refreshed by several years of work on those two projects – as well as on assignments that took him, among other places, to Shakespearean England, to the Japan of Hiroshige's woodcut series of views along the Tokaido Road, and throughout America to photograph festivals – Stock was able to return to California in 1968 with a sense of humor. He went to photograph the production of "The Planet of the Apes" for Twentieth Century Fox and as an experiment took actors in full ape costume and makeup off the set and out into the streets. When passersby failed to show any surprise, Stock became obsessed with the surrealism of everyday life, especially of Californian life. He spent five weeks driving all over the state, focusing particularly on the bizarre juxtapositions that are the essence of surrealism. (One of the fundamental texts of the surrealist movement was that in which its nineteenth-century precursor, the French poet Lautréamont, praised the beauty of an "accidental encounter of a sewing machine and an umbrella on an operating table.") In his photographs of California and in his anticipation of their themes in his pictures of American festivals, Stock comes closest not only to the spirit of Cartier-Bresson but also to that of Elliott Erwitt, Magnum's foremost humorist. In his book "California Trip" Stock carried the theme of comical juxtapositions from the individual images to the layout that he designed, with an effect that can be seen in the California and Festival chapters of the present book.

Although many of Stock's California photographs comment on the vacuity and the grotesqueness of which there seem to be exceptional concentrations in that state, in the Haight-Ashbury section of San Francisco the photographer found much to admire in the hippies, who were developing an entirely new way of life. Consequently, he spent much of the year 1969 there and in several communes in the Southwest, accompanied by "Look" magazine writer William Hedgepeth. Together they visited such communes as Drop City in southern Colorado and the Lama Foundation, New Buffalo, and Lorien, all in New Mexico. In their resulting book, "The Alternative," they hailed the communal movement as arising out of a widely held sense of an urgent need to reject the soul-destroying values of competitive society. Although conceding that "at present, communes are unfinished phenomena in which life is neither ideal nor idyllic," the photographer and the writer acclaimed the "self-exiled" commune dwellers as the pioneers of a new society. We can clearly discern Stock's voice in the book's observation that the hippies "find that to exist is to

die Lektüre seiner Schriften und die umbrische Landschaft, hatte Stock eine Vision. Nach dieser Erscheinung begab er sich auf eine zehnjährige Weltreise, um jene universelle Schöpferkraft abzubilden, die Franz von Assisi »Bruder Sonne« genannt hatte. Er photographierte die Sonne jedoch nicht direkt, sondern fing ihre Reflexe auf den Rändern natürlicher Formen ein und spielte mit dem Schimmer ihres Lichts, ihren Strahlen und dem Schatten als graphische Elemente. Gleichzeitig arbeitete er an einer weiteren, durchaus ähnlichen Serie über den Zyklus der Jahreszeiten. Stock fragte sich, warum Menschen immer so negativ seien, wenn doch in der Natur auch dem strengsten Winter ein Frühling in all seiner Pracht folge.

Beflügelt durch die Arbeit an diesen beiden Projekten und durch einen Auftrag, der ihn unter anderem nach England führte, dem Land Shakespeares, und nach Japan mit den Holzschnitten Hiroshiges, die die Stationen des Tokaido-Weges beschreiben, und durch ganz Amerika, wo er die Festivals photographierte, konnte Stock 1962 schließlich mit heiterer Gelassenheit nach Kalifornien zurückkehren.

Er dokumentierte die Dreharbeiten zu »Planet of the Apes« für die Twentieth Century Fox, in deren Verlauf er mit den Schauspielern zusammen ein Experiment machte und sie im Affenkostüm und mit Maske durch die Straßen von Los Angeles schickte. Als er feststellte, daß die Passanten davon keinerlei Notiz nahmen, packte ihn eine Art Besessenheit: er war fasziniert vom Surrealismus des täglichen Lebens, gerade in diesem Staat. Fünf Wochen fuhr er nun quer durch Kalifornien und nahm besonders bizarre Widersprüchlichkeiten aufs Korn, aus denen das Surrealistische ja im wesentlichen besteht. (In einem Schlüsseltext der Surrealisten preist ihr Vorläufer des 19. Jahrhunderts, der französische Dichter Lautréamont, die Schönheit der »zufälligen Begegnung einer Nähmaschine und eines Regenschirms auf einem Operationstisch«.) Mit seinen Aufnahmen von Kalifornien und den Photos amerikanischer Festivals, in denen dasselbe Thema bereits anklingt, nähert sich Stock nicht nur dem Geist von Cartier-Bresson, sondern auch Elliott Erwitt, dem größten Humoristen von Magnum. In seinem Buch »California Trip« übertrug Stock das Schema bizarrer Kombinationen in den Aufnahmen auch wirkungsvoll auf das Layout; im vorliegenden Buch wird dies besonders in den beiden Kapiteln über Kalifornien und die Festivals deutlich.

Obwohl viele von Stocks Aufnahmen aus Kalifornien das Leere und Groteske dort kommentieren, entdeckte er bei den Hippies von Haigth-Ashbury vollkommen neue Lebensformen, die er bewunderte. So verbrachte er im Jahr 1969 zusammen mit William Hedgepeth, der für die Zeitschrift »Look« schrieb, viel Zeit in dieser Gegend und in verschiedenen anderen Kommunen im Südwesten Amerikas. Sie besuchten die Kommune »Drop City« im Süden Colorados sowie die »Lama Foundation«, »New Buffalo« und »Lorien« in New Mexico. In ihrem gemeinsamen Buch »The Alternative« feiern sie die Kommunen als eine Bewegung, die aus dem weitverbreiteten, starken Bedürfnis entstanden war, sich den seelenlosen Werten der Konkurrenzgesellschaft zu verweigern. Trotz der Einschränkung, daß »Kommunen derzeit unvollendete Phänomene [seien], in denen das Leben weder ideal noch idyllisch ist«,

become related with others, and instinctively attuned, as well, to the sunny sanity of Nature with a wakened spirit of sustained wonder."

To reach the new world of the communes, or simply to wander in search of their dreams, the hippies – alienated refugees – hitchhiked or took to the road in converted schoolbuses. Photographing that phenomenon led Stock to spend a year documenting the American passion for mobility as an expression of individualism. As a sort of powerfully motorized horse or as an automobile for one, the motorcycle – one of Jimmy Dean's preferred forms of transportation – is perhaps the ultimate such expression, though it is paradoxical that motorcyclists like to travel in closely-knit tribes with a conformity of dress as rigidly enforced as that prevailing on Wall Street. Stock certainly felt an affinity for the nomadic hippies who lived in their buses and campers. "I like to be on the road," he told one interviewer. "The bottom line for the kind of photography I like, and the world I like, is based on discovery. … The photographers whom I've admired the most are curious people. We want to know what's around the next corner, and we're willing to forsake in many instances the creature comforts to find out."

Since the early 1970s, when Stock shot the last of the photographs included in this book, his work has taken him around many corners to work on books of color photographs – back to Japan, to Alaska and Hawaii, and throughout Europe in a camper. He has become an ardent advocate of environmental protection, and he has written that the many encounters he has had with native and rural people have supported his optimistic view of life. He now lives amidst the natural beauties of rural Provence.

Richard Whelan

priesen der Photograph und der Schriftsteller die »freiwillig exilierten« Kommunarden als Pioniere einer neuen Gesellschaft. In diesem Buch ist Stocks Ansicht deutlich herauszuspüren, daß für die Hippies folgendes gilt: »Zu existieren bedeutet, mit anderen in Kontakt zu sein und mit einem erwachten Bewußtsein für die Wunder der Natur ganz instinktiv ihrer Weisheit zu folgen.«

Um sich dieser neuen Welt der Kommunen anzuschließen oder einfach ihren Träumen nachzujagen, trampten die Hippies als »entfremdete Flüchtlinge« oder fuhren in umgebauten Schulbussen durchs Land. Stock nahm sich ein ganzes Jahr Zeit, diese Phänomene zu photographieren und dokumentierte damit die Leidenschaft der Amerikaner für Mobilität als Ausdruck von Individualismus. Wie eine Art motorisiertes Pferd oder Auto für eine Person verkörpert das Motorrad – James Deans bevorzugtes Fortbewegungsmittel – dies vielleicht am deutlichsten, wenn es auch paradox erscheint, daß Biker am liebsten in festen Verbänden fahren, mit einer rigiden Kleiderordnung, die dem Konformismus der Wallstreet in nichts nachsteht.

Stock spürte gewiß eine Affinität zu diesen nomadischen Hippies in ihren Bussen und Wohnmobilen. »Ich bin gerne unterwegs«, sagte er in einem Interview. »Photographie, die ich gut finde und die Welt, die mir gefällt, haben für mich immer etwas mit Entdeckung zu tun. [...] Die Photographen, die ich am meisten verehrt habe, sind alle neugierige Menschen. Wir möchten gerne wissen, was hinter der nächsten Ecke passiert und sind auch bereit, dafür auf Bequemlichkeit zu verzichten.«

Seit Beginn der siebziger Jahre, als Stock die letzten Aufnahmen für das vorliegende Buch machte, hat er durch seine Arbeit an Publikationen mit Farbphotographie vieles gesehen, während er Japan, Alaska, Hawaii und Europa in einem Wohnmobil bereiste. Stock ist zu einem engagierten Umweltschützer geworden und schrieb, daß seine Begegnungen mit Eingeborenen und Menschen, die auf dem Land leben, seine positive Lebenseinstellung gestützt hätten. Heute lebt er in einer schönen, ländlichen Gegend der französischen Provence.

Richard Whelan

PHOTOGRAPHS

This story was the first of a significant few that had a decisive effect on my future. It was ironic that it was a story about "arriving." In 1951 the West was obliged to open its doors to those Eastern Europeans who were oppressed by the communists. New York's harbor again welcomed passenger ships packed with refugees. Reminded of the photographs of Lewis Hine, of an earlier period, I sought images that expressed the anxieties and hope of America's next major arrival of immigrants. The universality of the event unfolding with each visit that I made at the docks assured me that I was connecting my senses to a very poignant subject, a highly graphic drama.

REFUGEES

Diese Geschichte ist die erste aus einer Reihe von Ereignissen, die von entscheidender Bedeutung für meine Zukunft waren. Ironischerweise ging es in dieser Geschichte um »Ankommen«.

1951 war der Westen gezwungen, seine Grenzen für Menschen aus Osteuropa zu öffnen, die vor den kommunistischen Machthabern auf der Flucht waren. Im Hafen von New York empfing man die mit Auswanderern überfüllten Passagierschiffe. Mit Photographien von Lewis Hine aus früheren Jahren im Kopf war ich auf der Suche nach Bildern, die die Ängste und Hoffnungen der nun abermals in Scharen eintreffenden Auswanderer zum Ausdruck brachten. Angesichts dieser bedeutenden Szenen, die sich bei jedem Besuch auf den Docks vor meinen Augen abspielte, hatte ich das Gefühl, Zeuge eines ganz besonderen, ergreifenden, dramatischen Vorgangs zu sein.

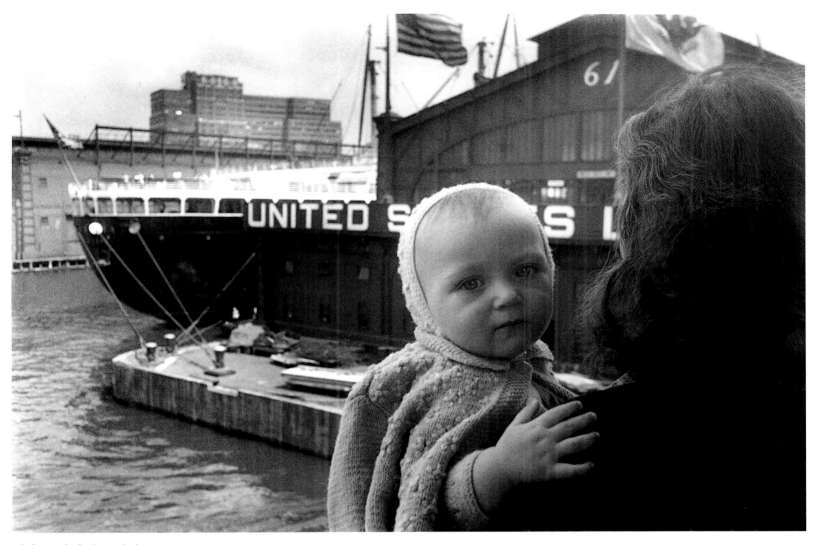

33

A baby's arrival Ein Baby kommt an

34

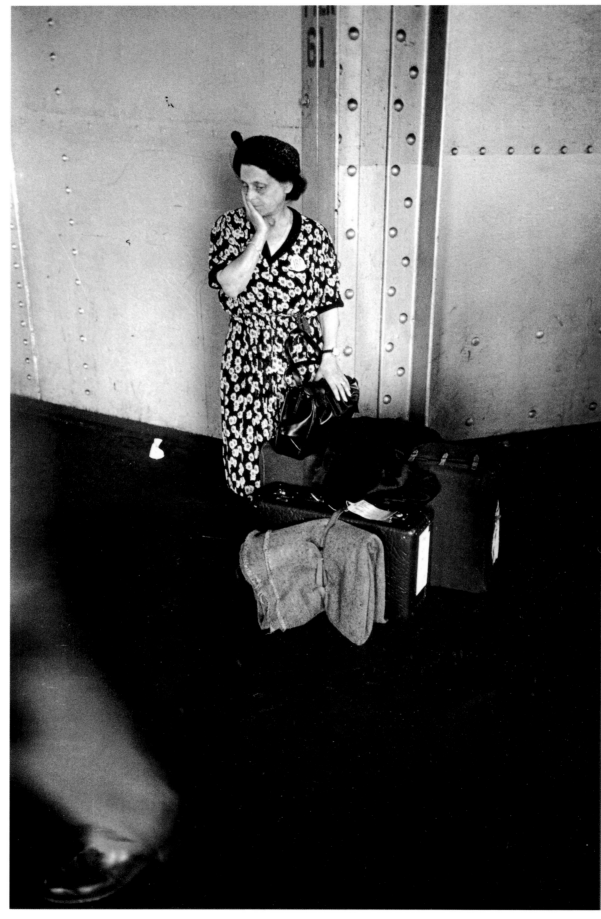

Refugee still aboard in New York harbor Noch an Bord im Hafen von New York

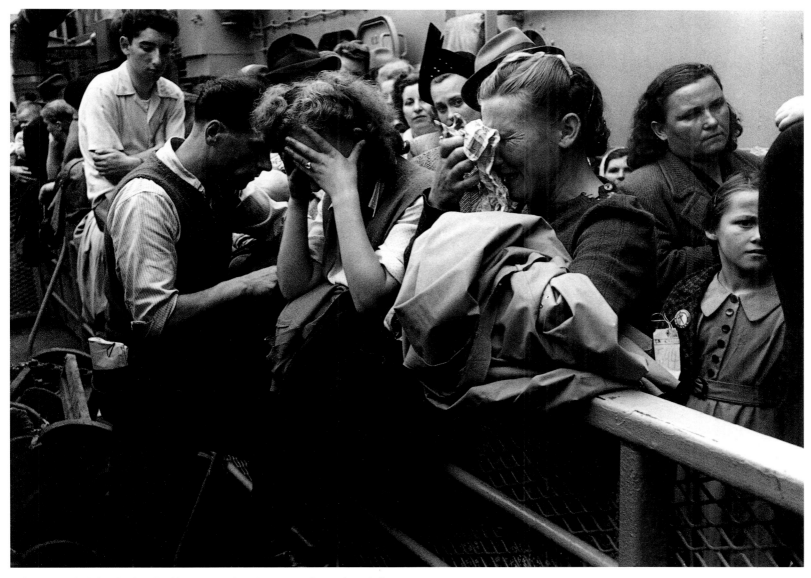

Refugees shortly before leaving the ship Einwanderer kurz vor Verlassen des Schiffs

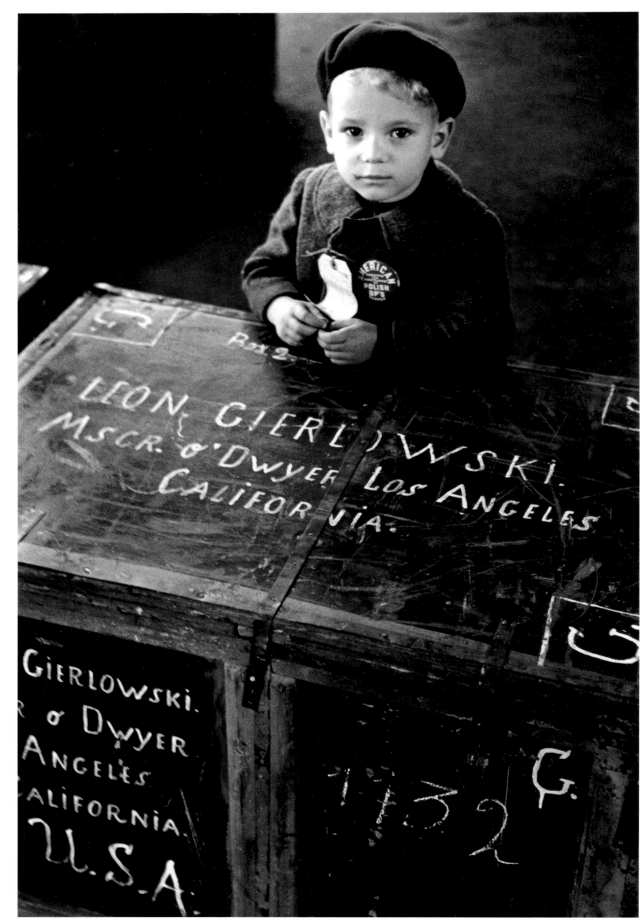

A new face for the new world Ein neues Gesicht für die »Neue Welt«

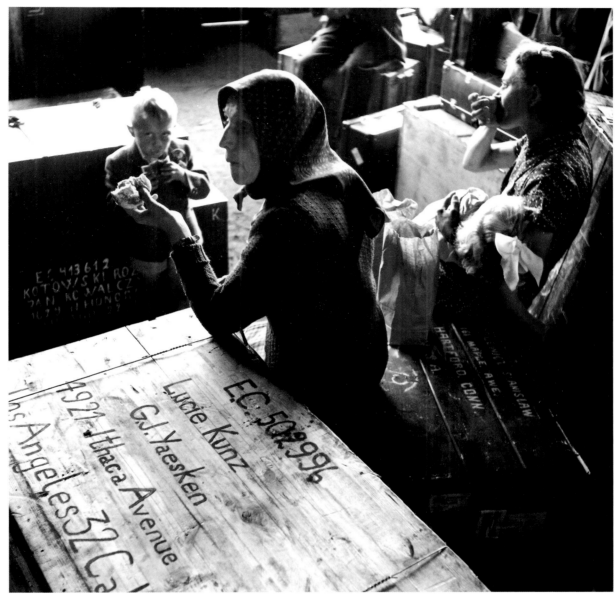

The first meal on American ground Die erste Mahlzeit auf amerikanischem Boden

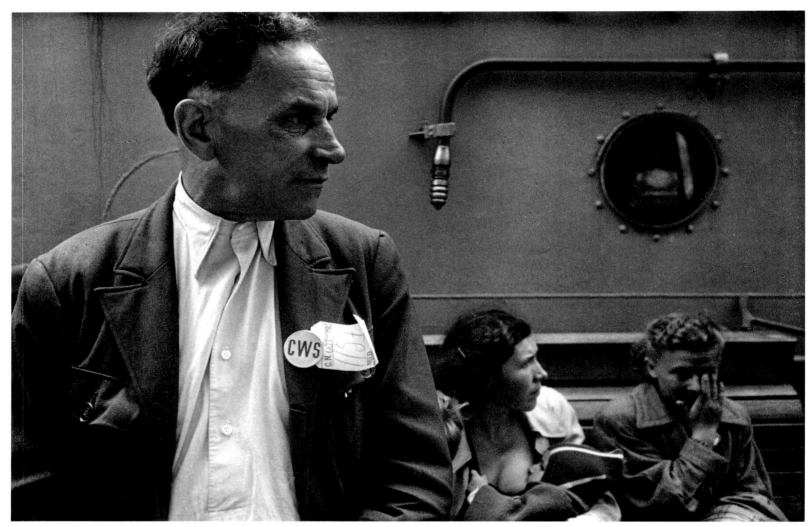

Waiting aboard Warten an Bord des Schiffs

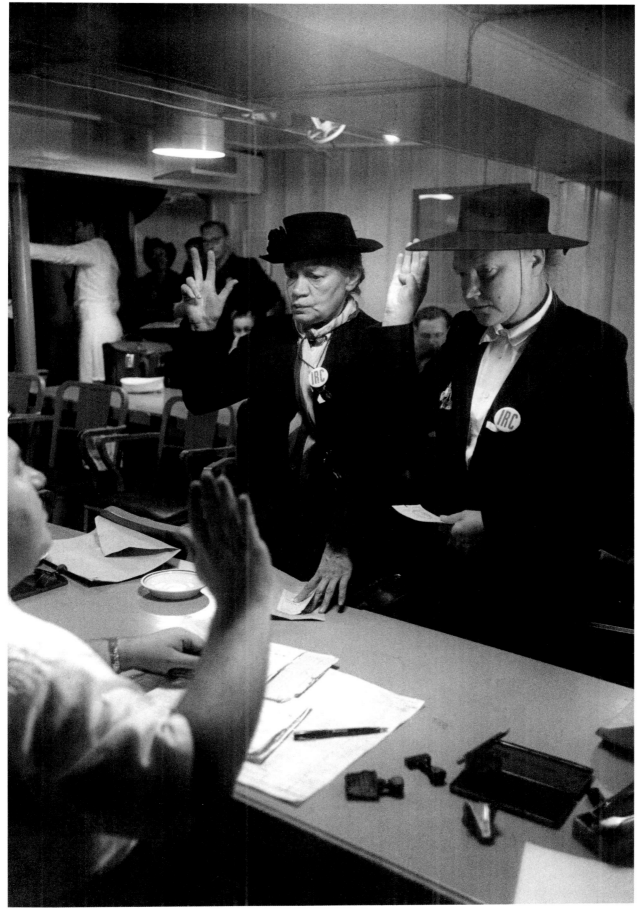

Bureaucratic absurdity – demanding an assurance of "No communist affiliation" Absurde Bürokratie: der »antikommunistische Eid«

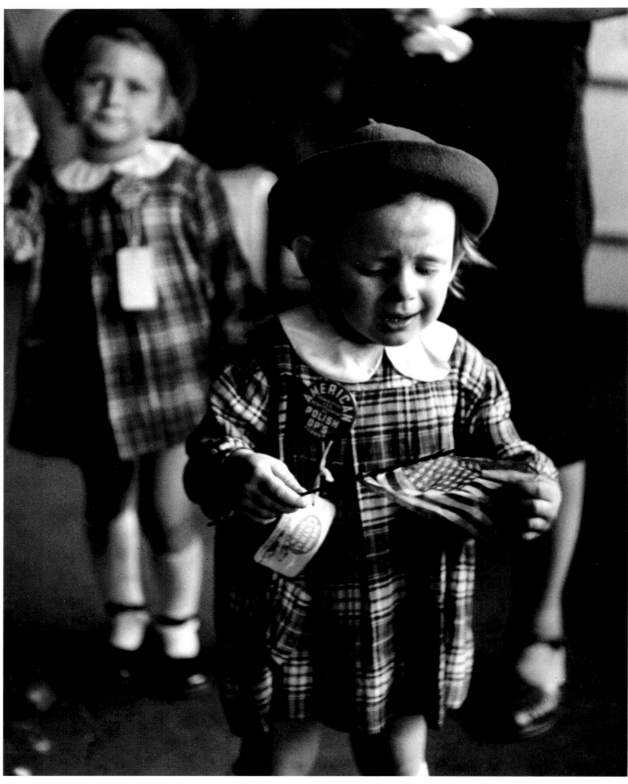

All ages showed fear Angst kennt kein Alter

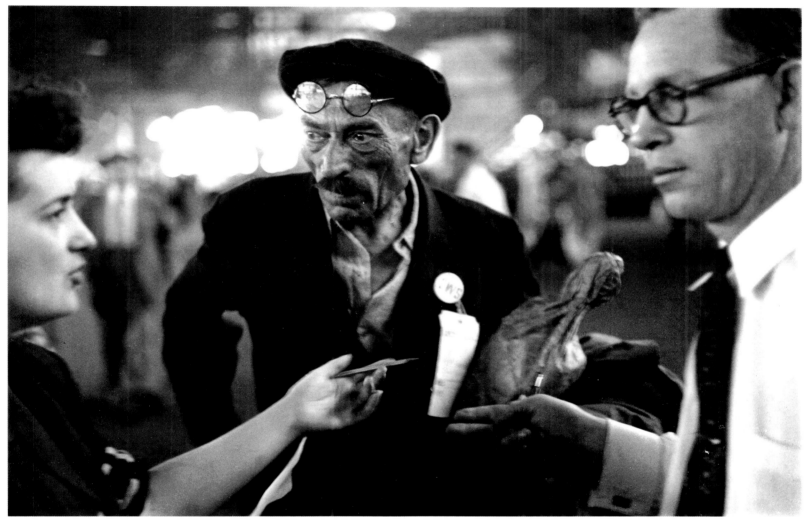

Refugee with immigration officers at New York dock Einwanderer und Behördenpersonal

Jazz musicians are of a somewhat suspicious nature. They have the right to be. They know that the public doesn't think much of them as people. I am therefore grateful for the way in which these men and women responded to the camera's intrusion. Their reactions moved from suspicion to acknowledgment, to curiosity, and finally to friendliness. My job was respected with the reservation that it should not interfere with their own. Often I was obliged to accept a fleeting moment in a busy musician's day. A moment can be enough. Improvisation, the essence of their art, dictated the form of this book. It often happened quickly; the photographic decision, like the jazz decision, must be instantaneous. I thoroughly enjoyed knowing the people, the artists who appear in this book. It is my intention that you have a comparable experience.

Most photos were taken in the years from 1958 to 1959; this preface for "Jazz Street" appeared in 1959.

JAZZ STREET

Jazzmusiker sind mißtrauisch. Mit Recht, weil sie wissen, daß das Publikum sie als Menschen nicht wirklich akzeptiert. Daher bin ich dankbar für die Art, wie diese Männer und Frauen auf die Zudringlichkeiten meiner Kamera reagiert haben. Aus Mißtrauen wurde Anerkennung, Neugier wandelte sich zu freundlichem Entgegenkommen. Meine Arbeit wurde respektiert, sie durfte nur nicht die ihre behindern. Oft mußte ich mich mit einem flüchtigen Moment im Tag eines vielbeschäftigten Musikers zufrieden geben. Aber ein Augenblick kann genügen. Improvisation, das Wesen des Jazz, bestimmt auch die Bilder dieses Buchs. Es hat mir große Freude gemacht, die Künstler kennenzulernen, die hier erscheinen, und ich wünsche mir, daß der Leser diese Erfahrung nachvollziehen kann.

Die meisten Photos entstanden zwischen 1958 und 1959; diese Einführung zu »Jazz Street« erschien 1959.

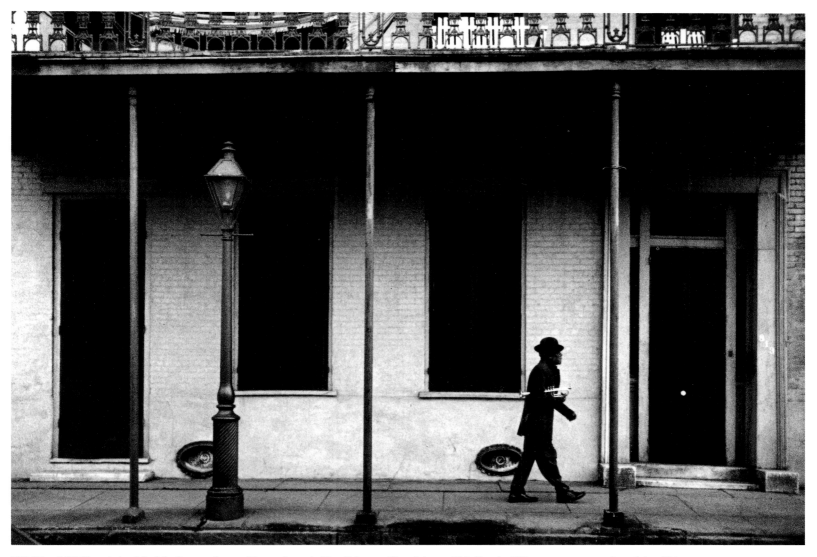

Kid "Punch" Miller, at six o'clock in the morning, on his way home in New Orleans New Orleans: Kid »Punch« Miller, morgens um sechs auf dem Heimweg

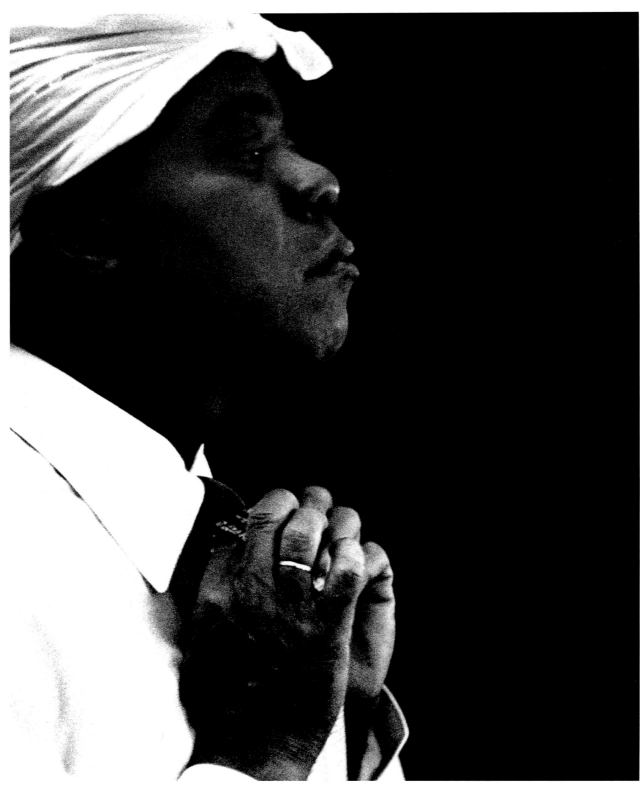

Louis Armstrong before performing at the "Latin Casino," Philadelphia
Louis Armstrong vor seinem Auftritt im »Latin Casino«, Philadelphia

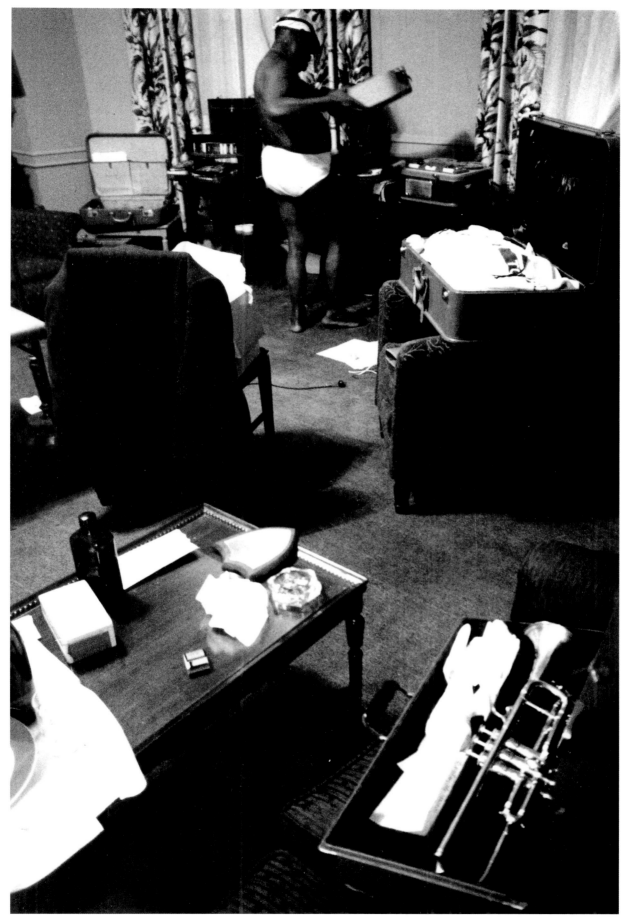

Louis Armstrong in his hotel room with trumpet, tapes, tape recorder, and suitcase
Louis Armstrong in seinem Hotelzimmer mit Trompete, Tonbandgerät und Koffer

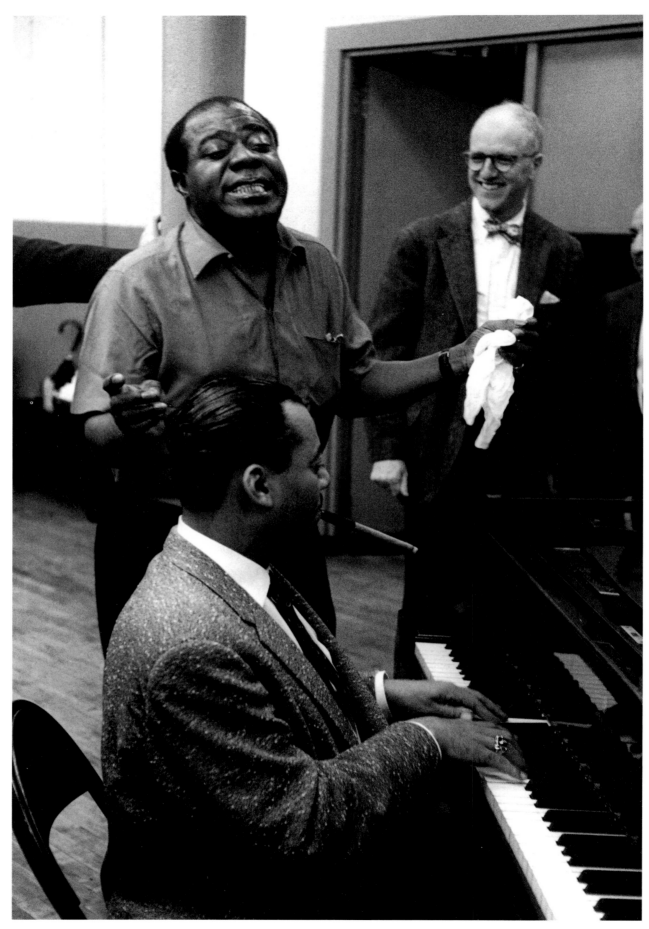

46

Rehearsing for a TV appearance, Louis Armstrong sings to Billy Kyle's accompaniment
Proben für einen Fernsehauftritt: Louis Armstrong singt, begleitet von Billy Kyle

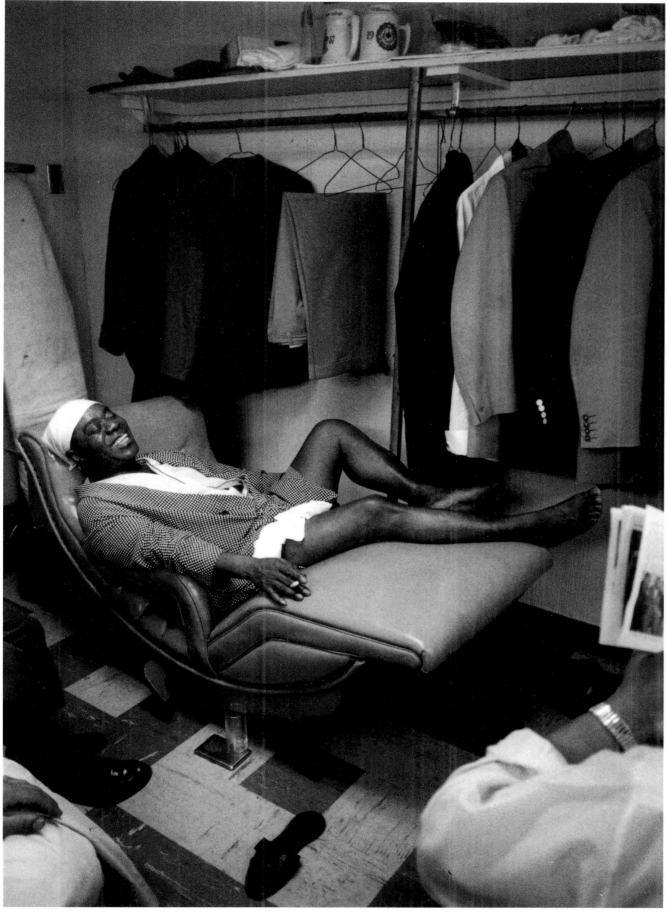

Louis Armstrong relaxes in the dressing room Louis Armstrong in der Garderobe

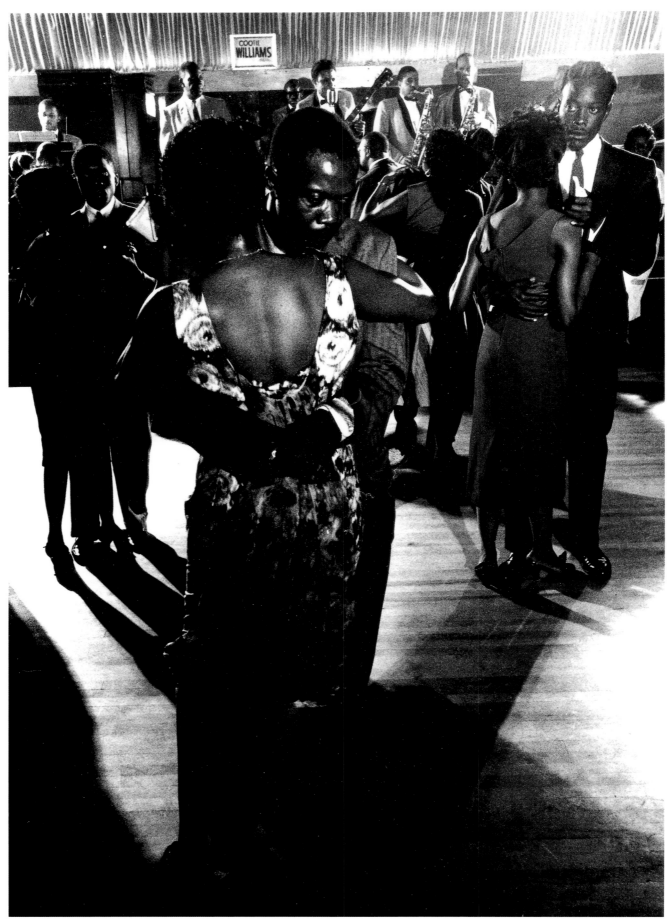

48

Savoy Ballroom, N.Y. Im Savoy Ballroom, New York

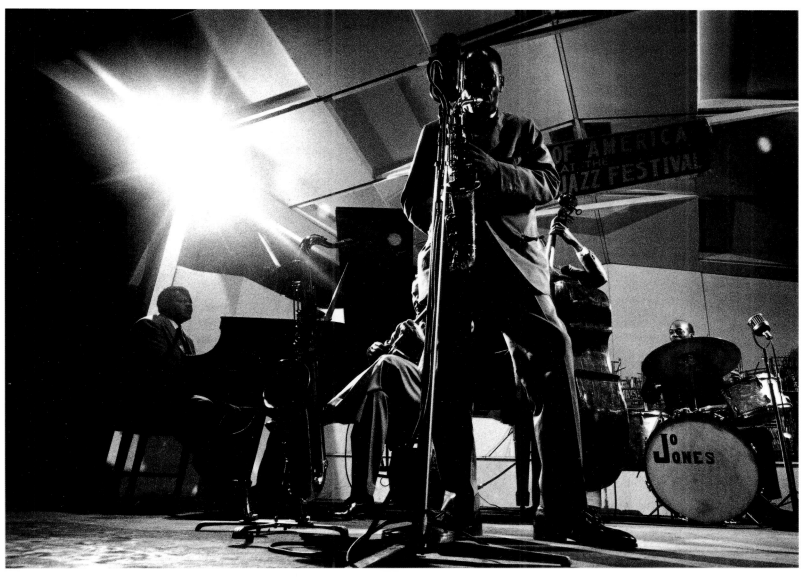

Sonny Stitt with the Oscar Peterson Trio and Jo Jones at the Newport Jazz Festival, Rhode Island
Sonny Stitt mit dem Oscar-Peterson-Trio und Jo Jones auf dem Jazzfestival in Newport, Rhode Island

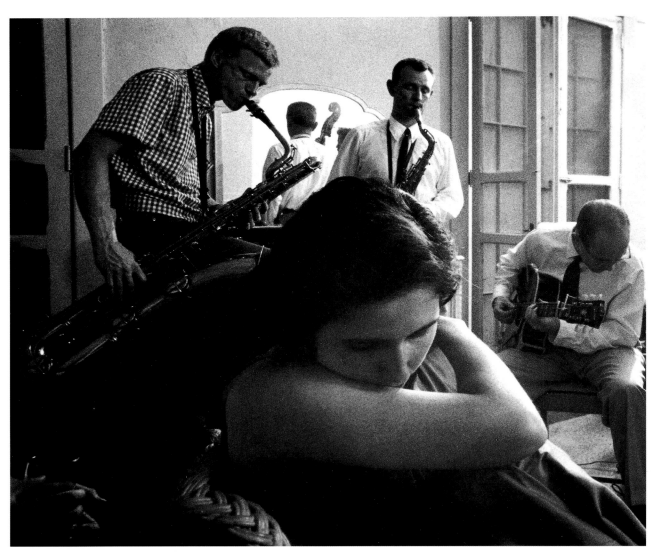

Gerry Mulligan in a jam session with Jimmy Giuffre, Jim Hall, and a friend at the Newport Jazz Festival, Rhode Island
Gerry Mulligan »jamt« mit Jimmy Giuffre, Jim Hall und einem Freund in einem Hotel in Newport, Rhode Island

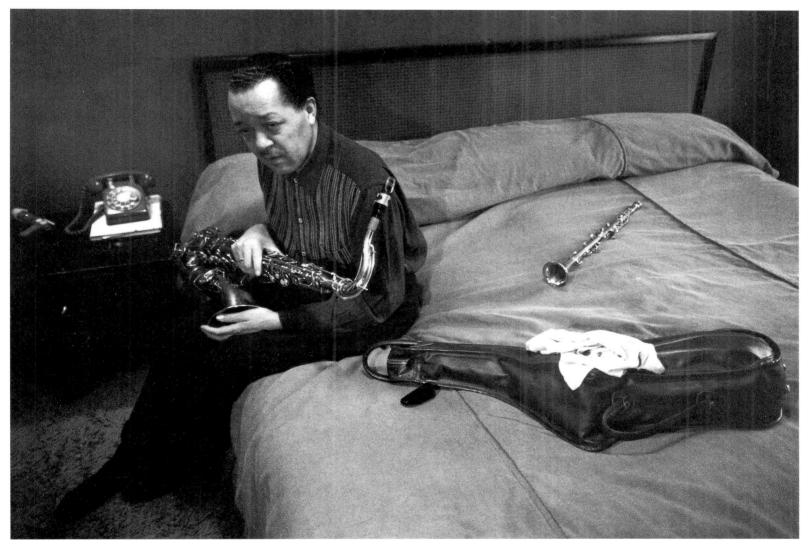

Lester Young at home, St. Albans, Queens, N.Y. Lester Young zu Hause in St. Albans, Queens, New York

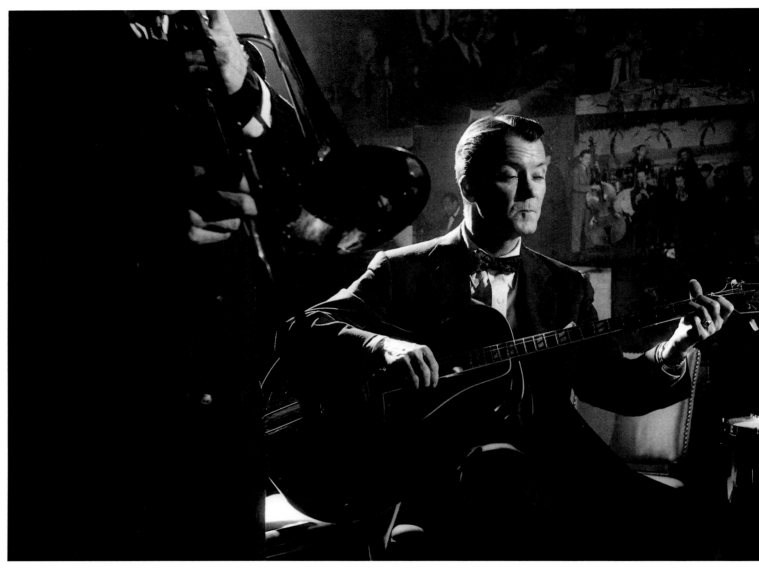

Eddie Condon in his club on the East Side Eddie Condon in seinem Club auf der East Side

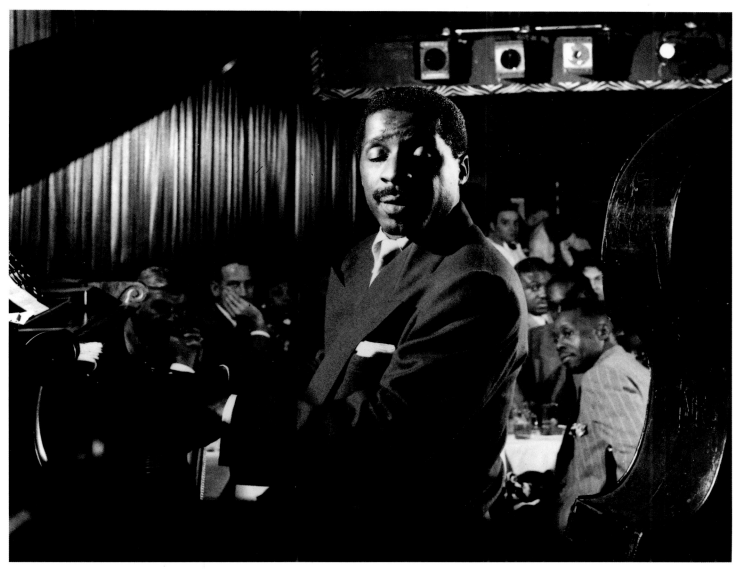

Errol Garner at the "Three Deuces," N.Y. Errol Garner im »Three Deuces«, New York

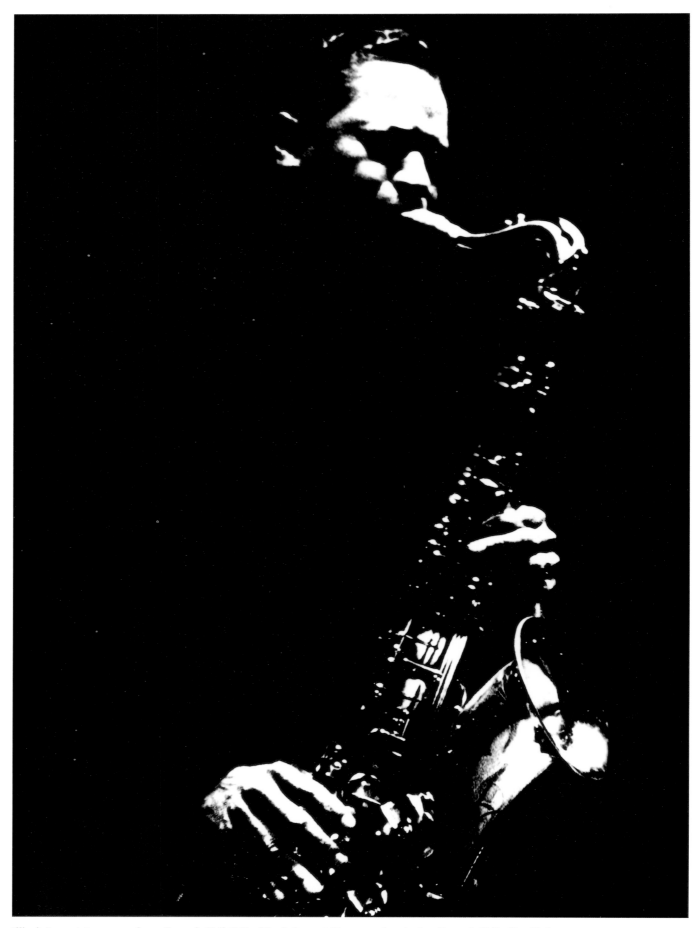

Illinois Jacquet, tenor saxophone, Carnegie Hall, N.Y. Illinois Jacquet, Tenorsaxophon, in der »Carnegie Hall«, New York

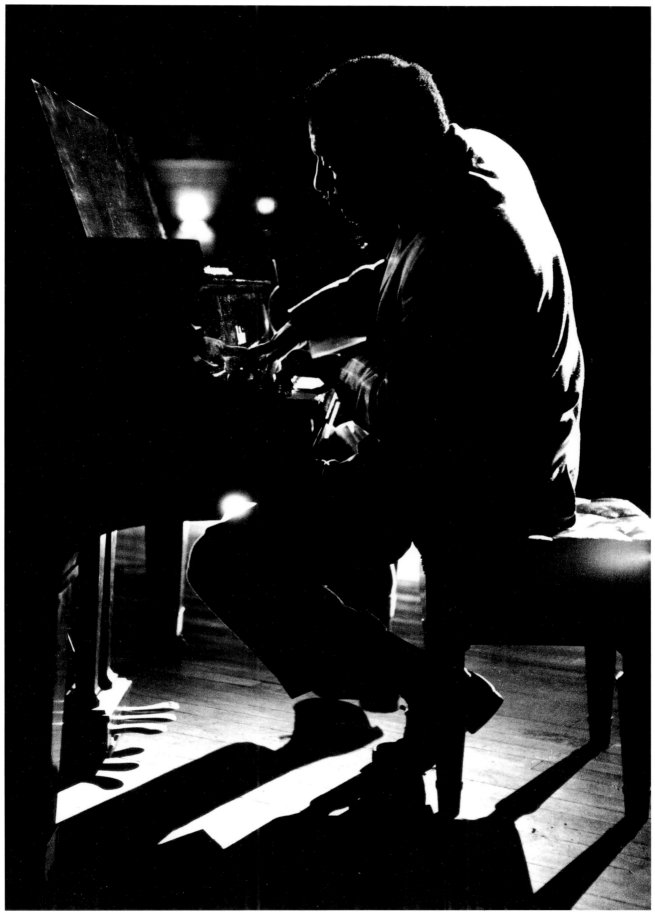

Thelonius Monk at the "Town Hall," N.Y. Thelonius Monk in der »Town Hall«, New York

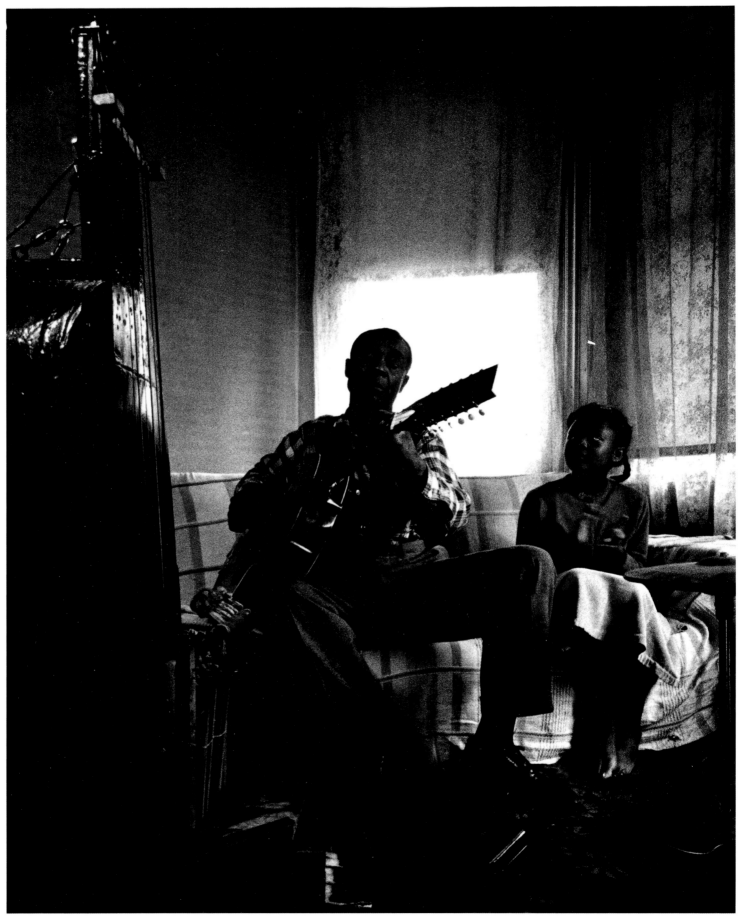

Jesse Fuller with daughter Jesse Fuller mit Tochter

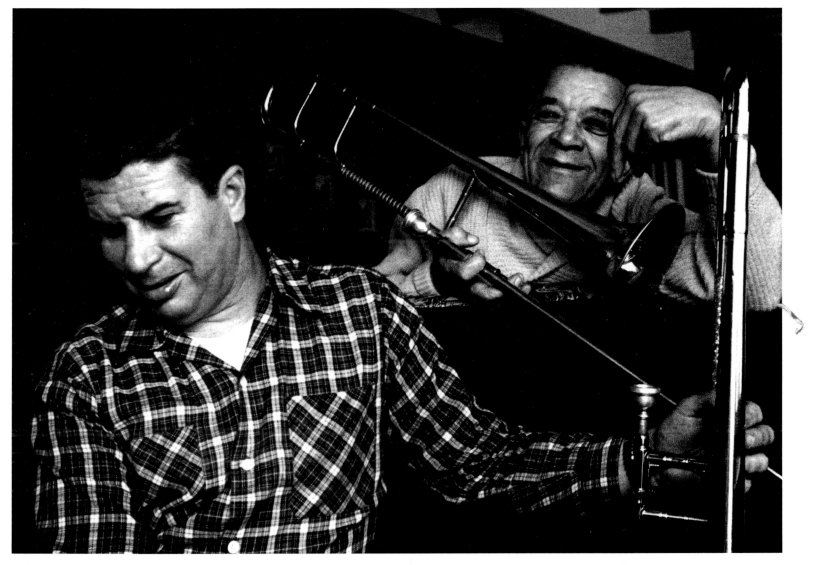

Turk Murphey and Kid Ory at Kid Ory's home in San Mateo, near San Francisco Turk Murphey und Kid Ory in Kid Orys Haus in San Mateo bei San Francisco

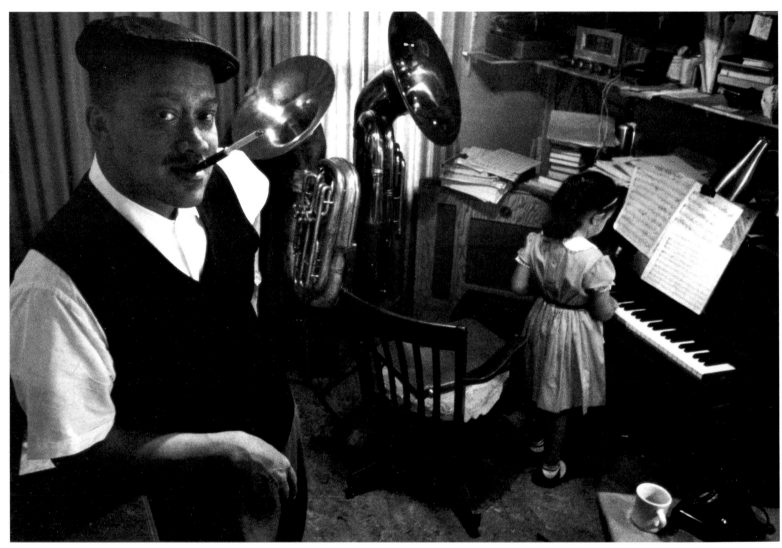

Red Calendar at home Red Calendar zu Hause

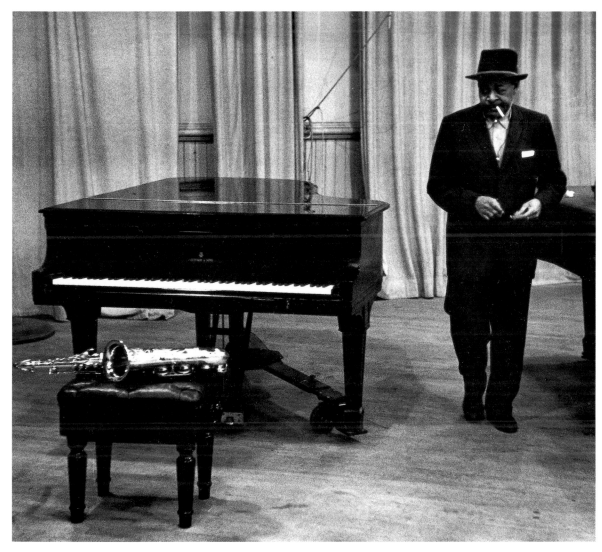

Coleman Hawkins, tenor saxophone, at recording session Coleman Hawkins, Tenorsaxophon, bei Aufnahmen

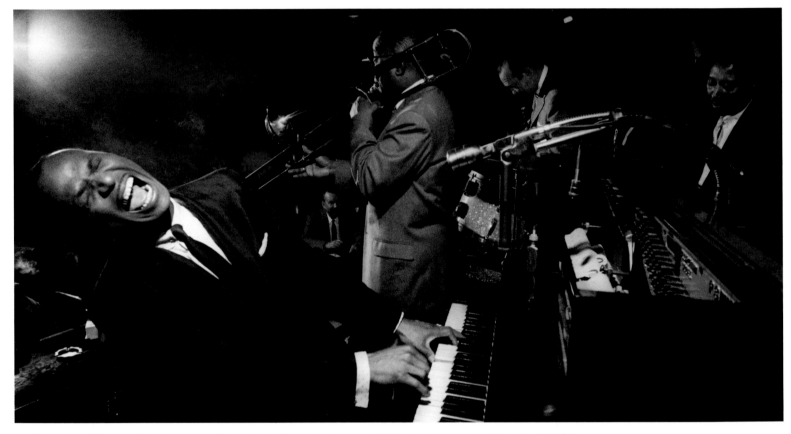

Earl Hines at the "Hangover," San Francisco, with trombonist Jimmy Archey, cornettist Muggsy Spanier, and drummer Earl Watkins
Earl Hines im »Hangover«, San Francisco, mit Posaunist Jimmy Archey, Kornettist Muggsy Spanier und dem Schlagzeuger Earl Watkins

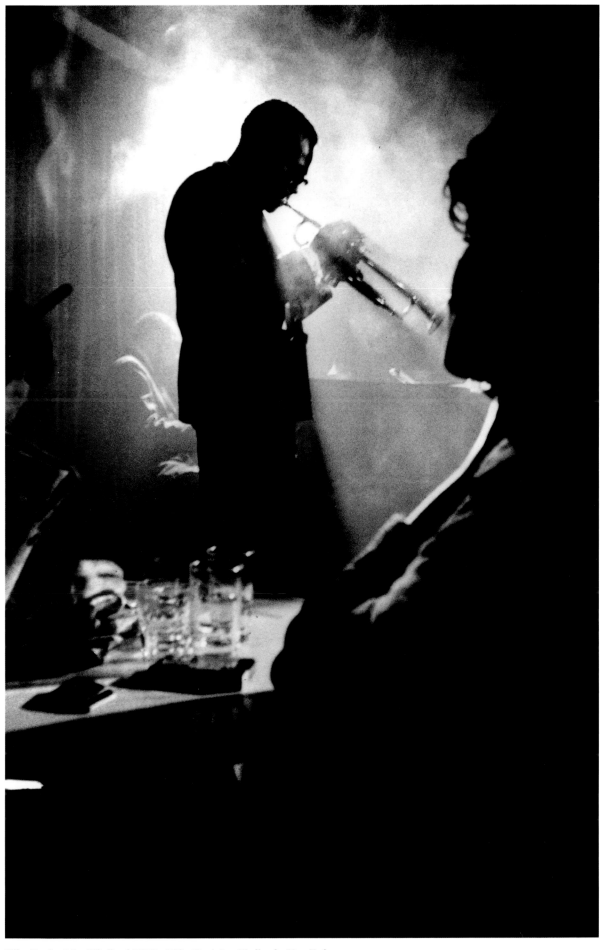

Miles Davis at the "Birdland," N.Y. Miles Davis im »Birdland«, New York

Anita O'Day, waiting, Village Vanguard, N.Y. Anita O'Day, Blick aus der Garderobe, Village Vanguard, New York

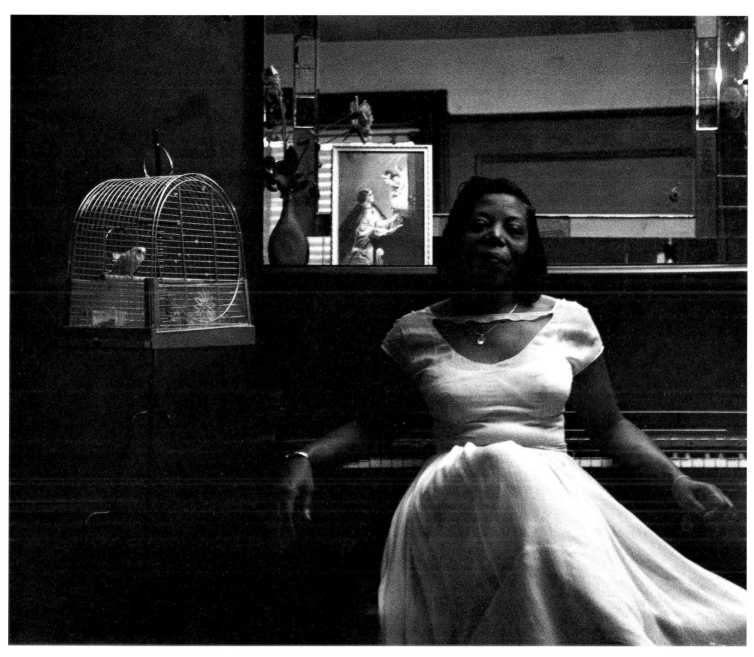

Mary Lou Williams, Washington Heights, N.Y. Mary Lou Williams, Washington Heights, New York

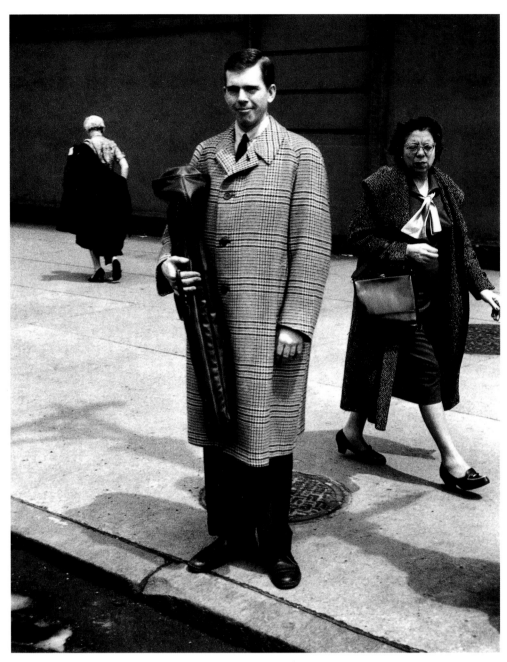

Bob Brookmeyer with his trombone on Broadway, N.Y. Bob Brookmeyer mit Posaune, Broadway, New York

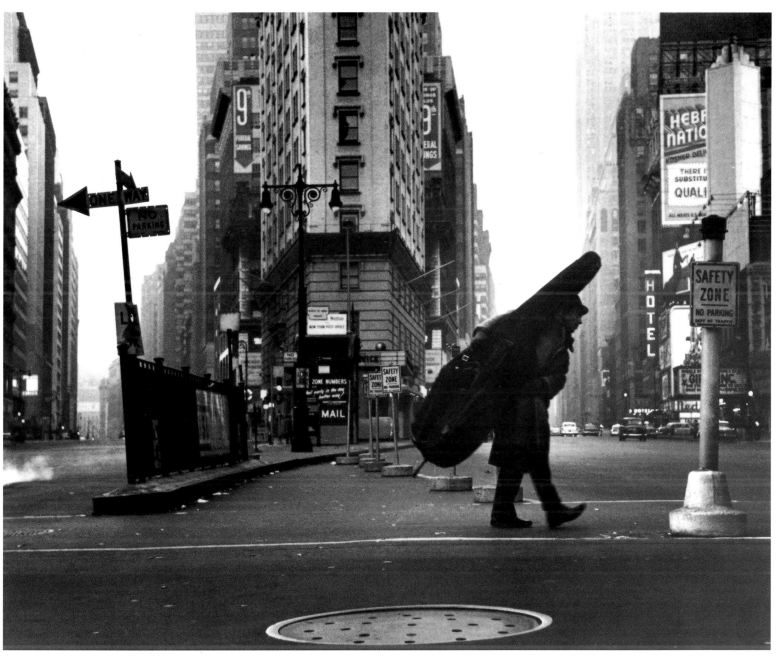

Bill Crow and his bass on their way home on Times Square at six o'clock in the morning Bassist Bill Crow morgens um sechs am Times Square, New York, auf dem Heimweg

Though I have contributed considerably to the myth of my friend James Dean by having taken most of the biographical photographs that illustrate his origins, the perpetuation of the legend mystifies me. The identification that each generation has with Dean makes it perfectly clear that he touches them, perhaps profoundly. In 1955, my motivation for doing a picture essay on James Dean was that I was deeply impressed by his acting and felt the necessity to photograph the environment that had affected and shaped his character. His small-town upbringing in Fairmount, Indiana, and the early professional years in New York were the influential past that we explored together.

JAMES DEAN

Obwohl ich Wesentliches zum Mythos meines Freundes James Dean beigetragen habe, weil die meisten Photos, die seine Geschichte und Herkunft beleuchten, von mir stammen, verwirrt mich die unzerstörbare Legende um seine Person. Daß sich die Menschen jeder Generation bisher mit ihm identifiziert haben, zeigt deutlich, wie sehr sie von seinem Spiel berührt waren. Im Jahr 1955 entschloß ich mich, ein Photoessay über James Dean zu machen, weil mich seine Schauspielkunst tief beeindruckte und ich es für wichtig hielt, das Umfeld, die Wurzeln zu zeigen, die sein Wesen beeinflußt hatten und ausmachten: Also besuchten wir gemeinsam die Kleinstadt Fairmount in Indiana, wo er aufgewachsen war, und gingen anschließend nach New York, wo er seine ersten Engagements gehabt hatte.

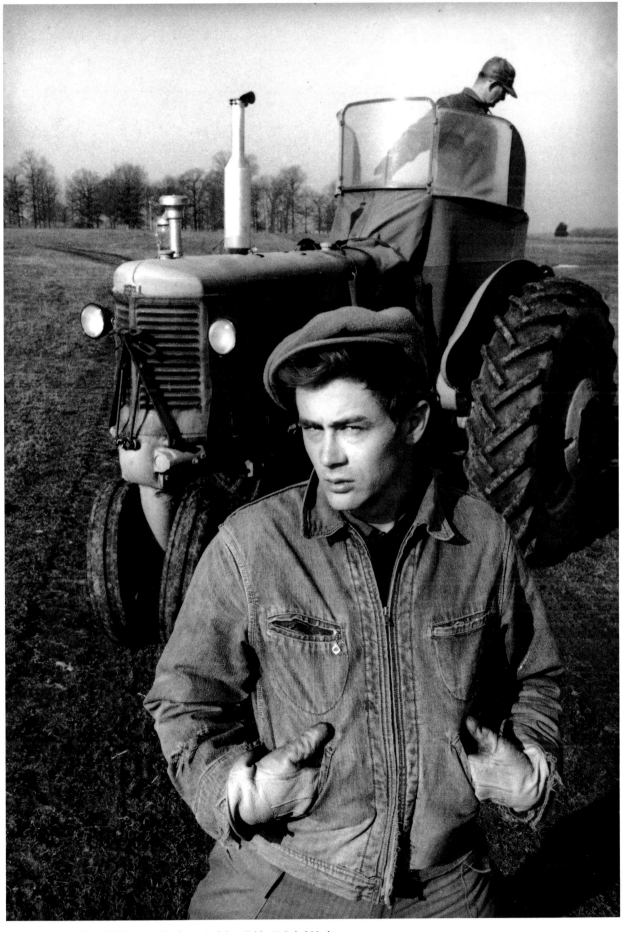

James Dean working with his uncle Markus Auf dem Feld mit Onkel Markus

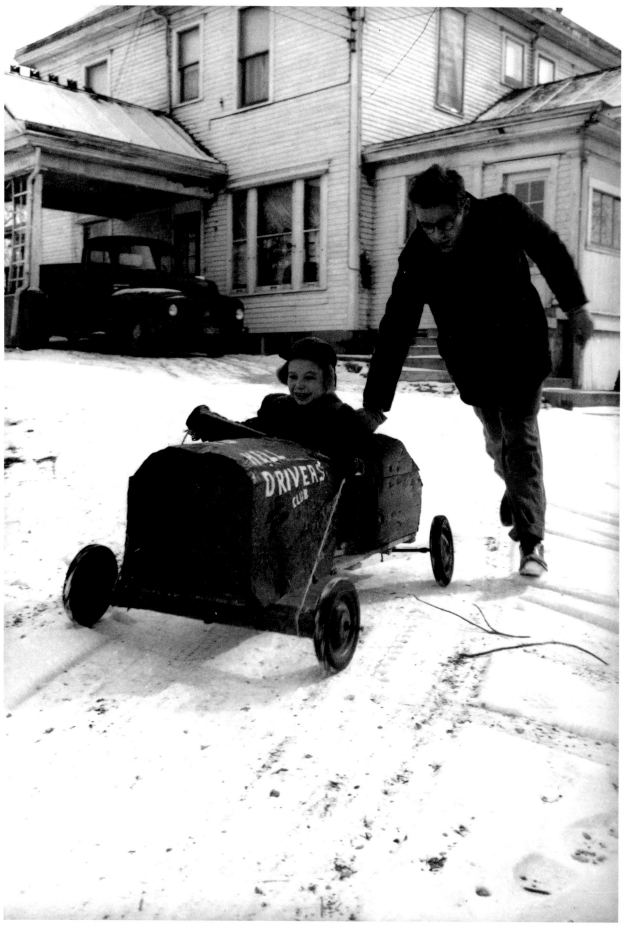

Soapbox-racing with his cousin Markie in the frontyard Seifenkistenrennen auf dem Hof mit Cousin Markie

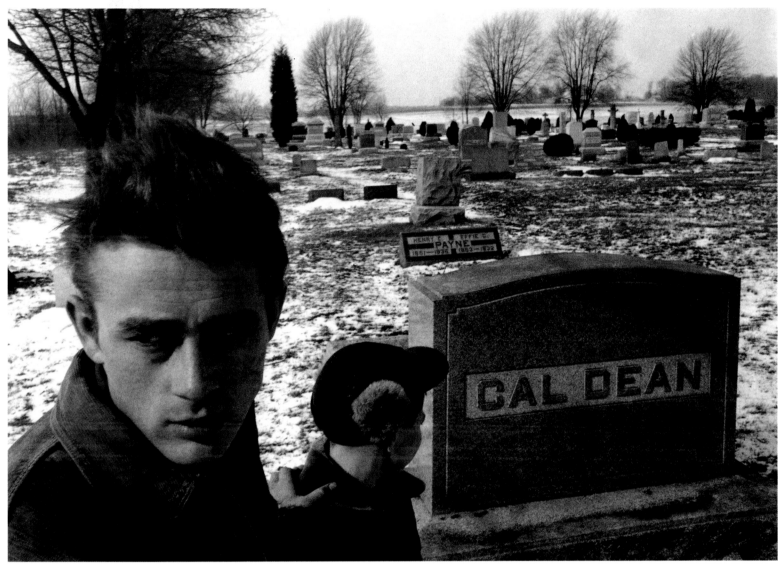

At the graveyard of Fairmount, in front of the grave of one of his ancestors Auf dem Friedhof in Fairmount vor dem Grabstein eines Vorfahren

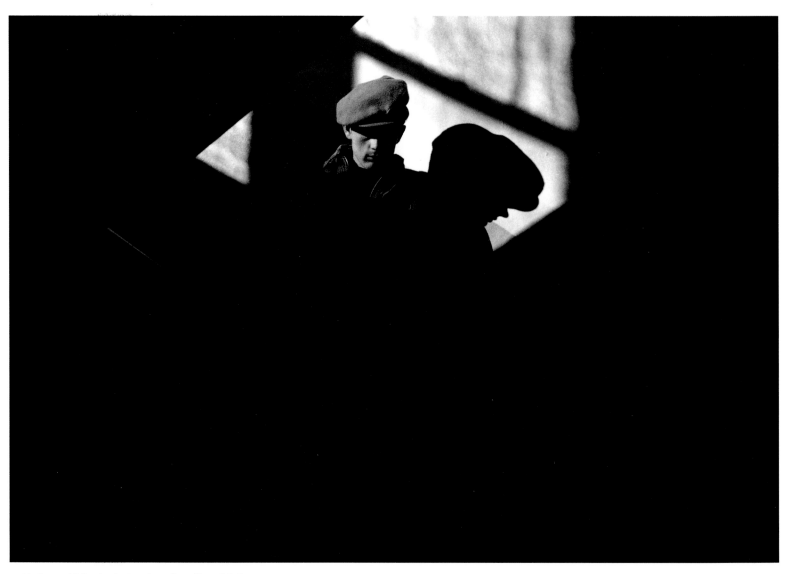

At his former high school In seiner ehemaligen Schule

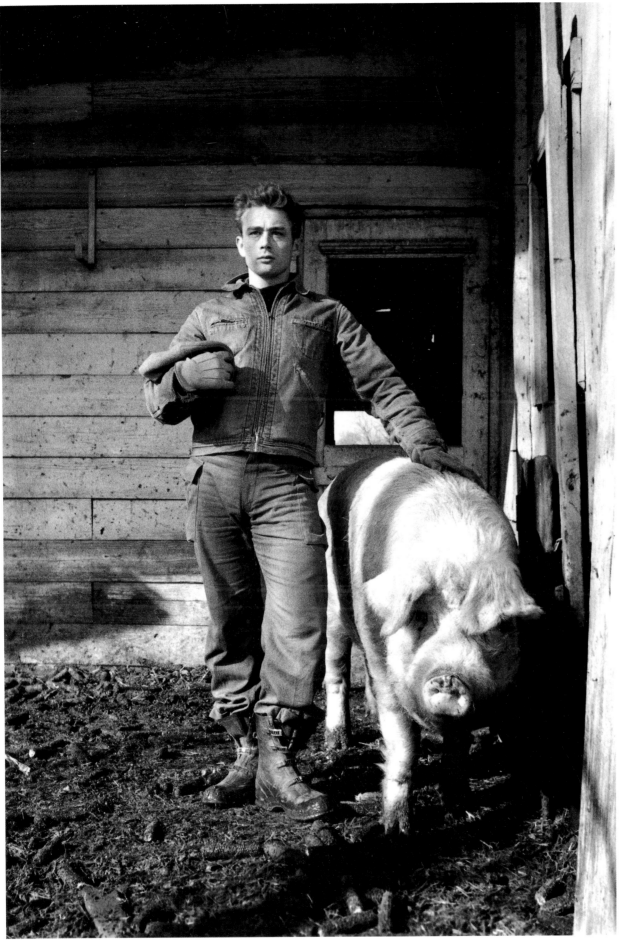

At Winslow Farm posing as an old-style portrait with a sow Auf der Winslow Farm in altertümlicher Pose mit Sau

72

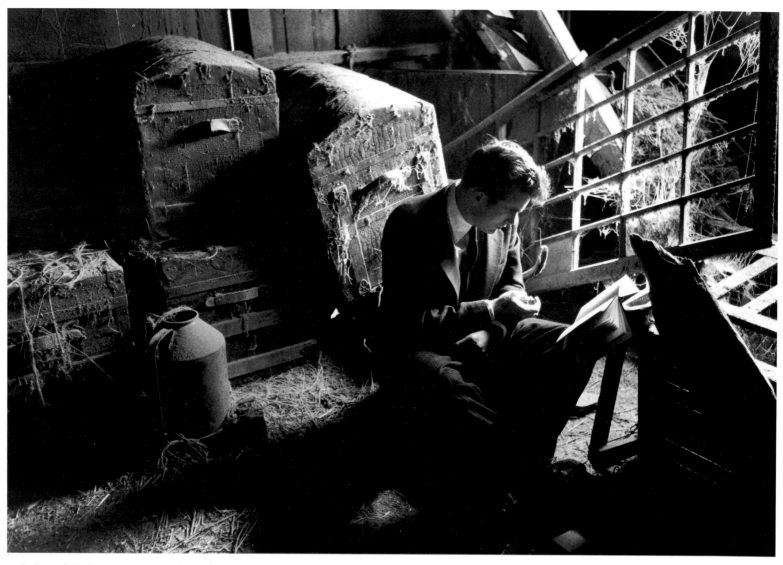

In the barn of Winslow Farm In der Scheune der Winslow Farm

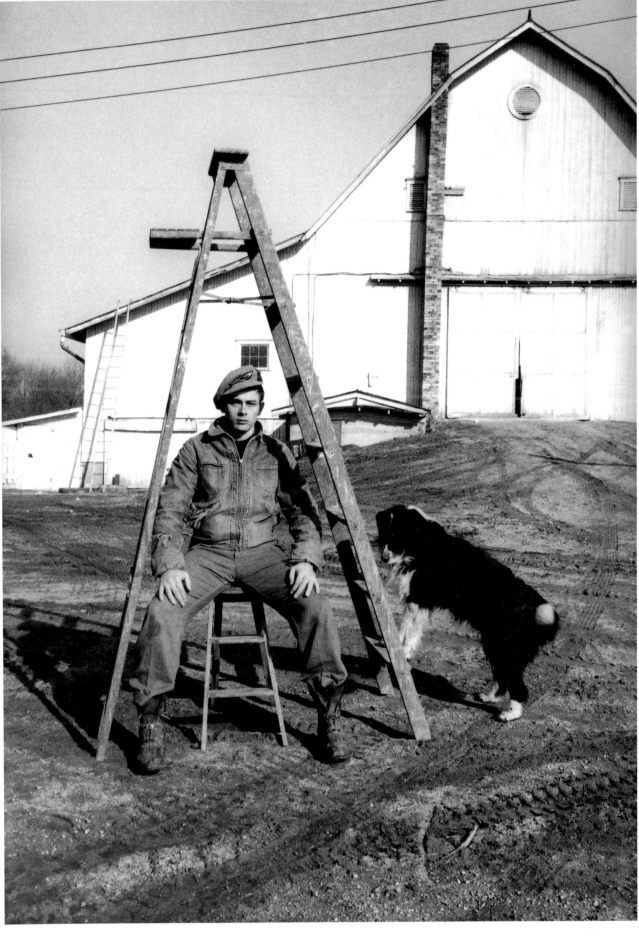

In front of the barn Vor der Scheune

At the old schoolroom at Fairmount High Im alten Schulhaus von Fairmount

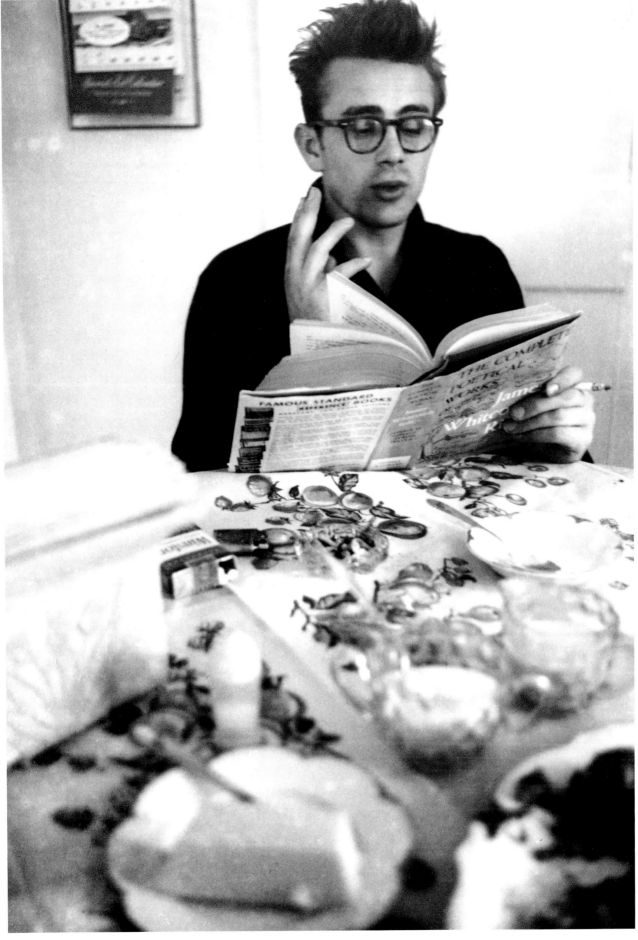

James Dean reciting his favorite poet, James Whitcomb Riley James Dean rezitiert seinen Lieblingsdichter James Whitcomb Riley

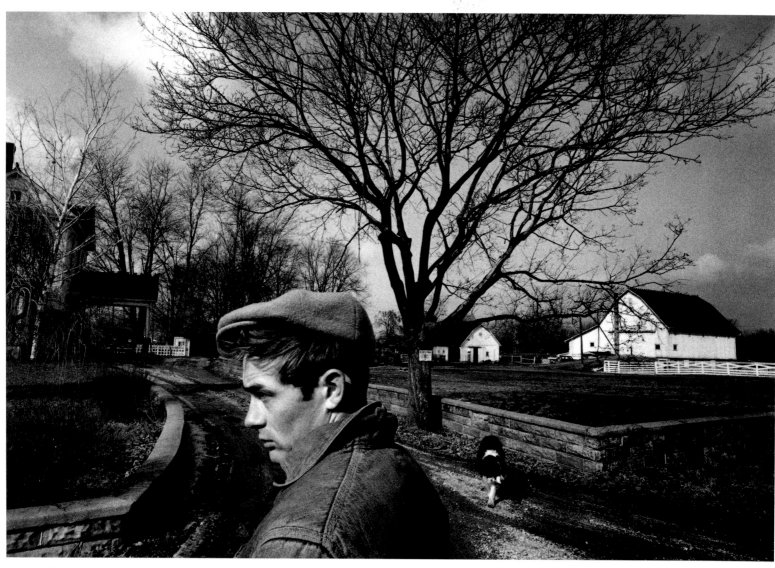

In front of the driveway to Winslow Farm Vor der Einfahrt zur Winslow Farm

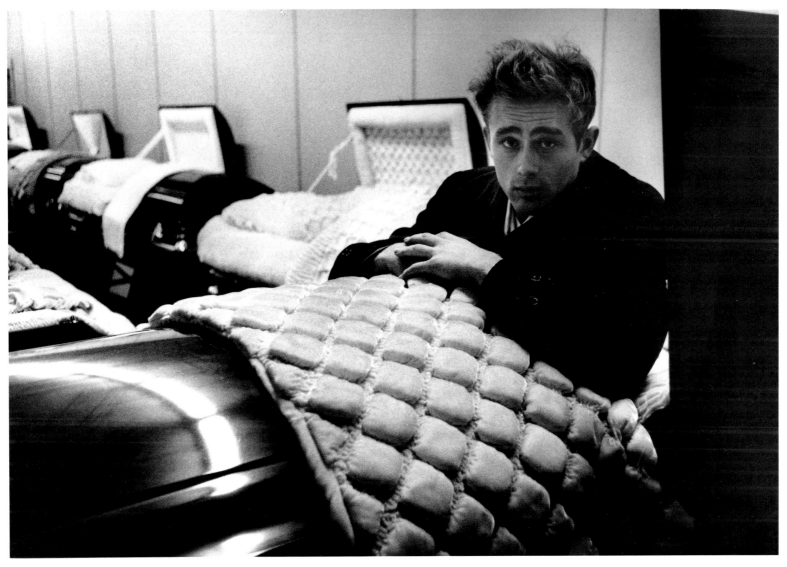

At "Hunt's Funeral Home" in Fairmount, poking fun at death Im Fairmounter Bestattungsinstitut »Hunt's Funeral Home«

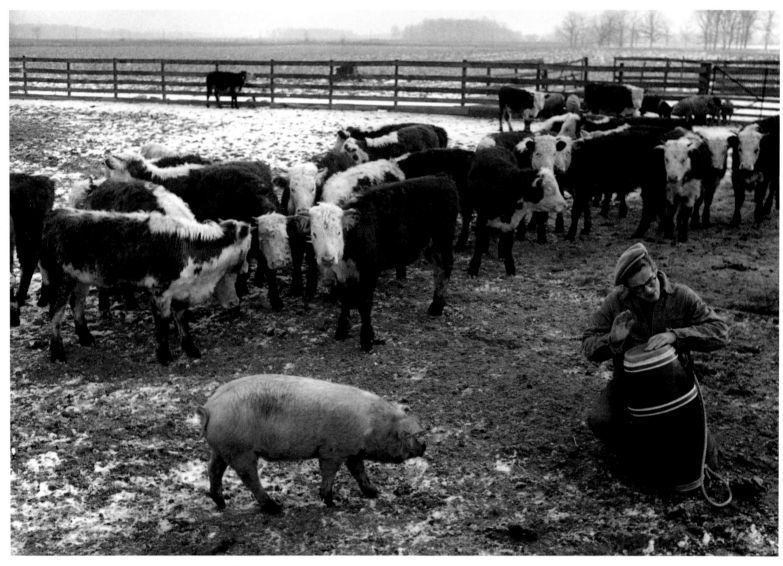

A solo on congas for pig and cows Congasolo für Schwein und Kälber

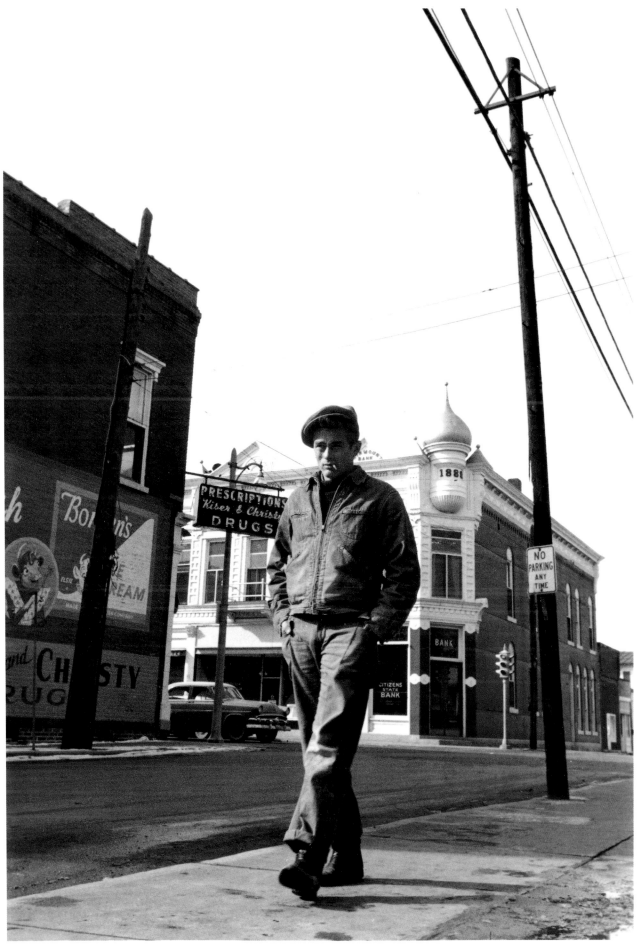

In the streets of Fairmount In den Straßen von Fairmount

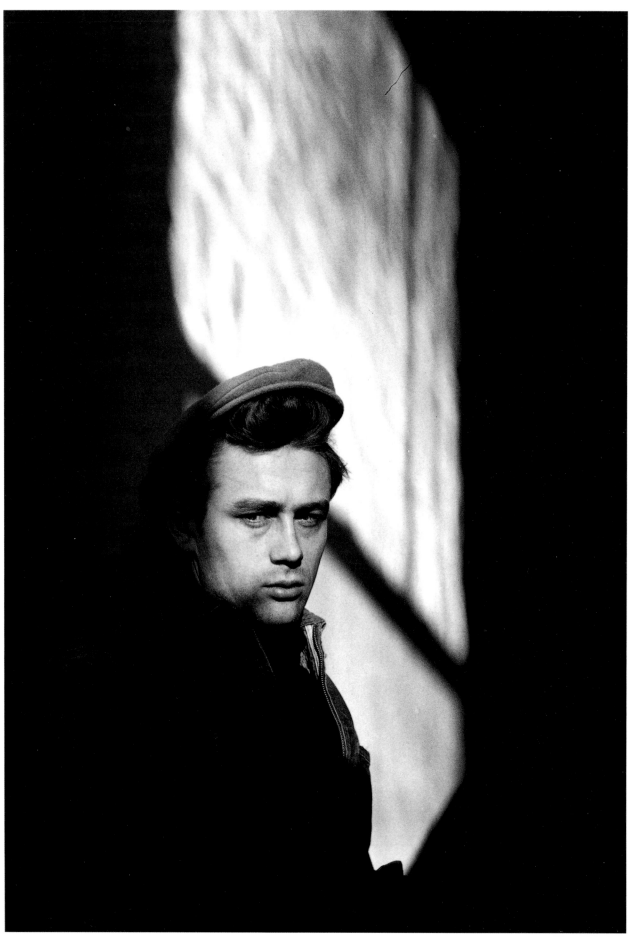

At the old schoolhouse of Fairmount Im alten Schulhaus von Fairmount

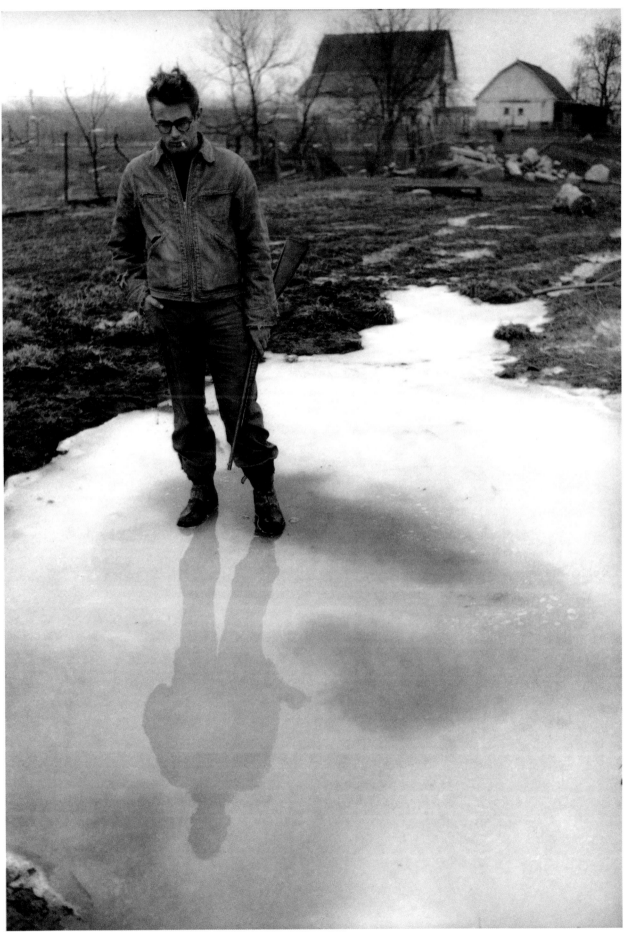

On Winslow Farm Auf der Winslow Farm

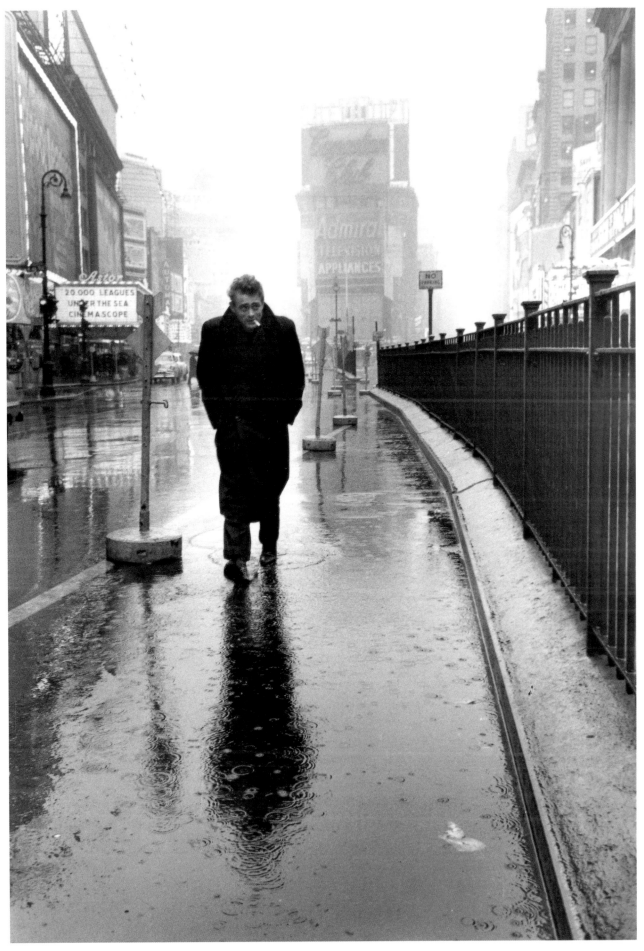

James Dean on Times Square Auf dem Times Square

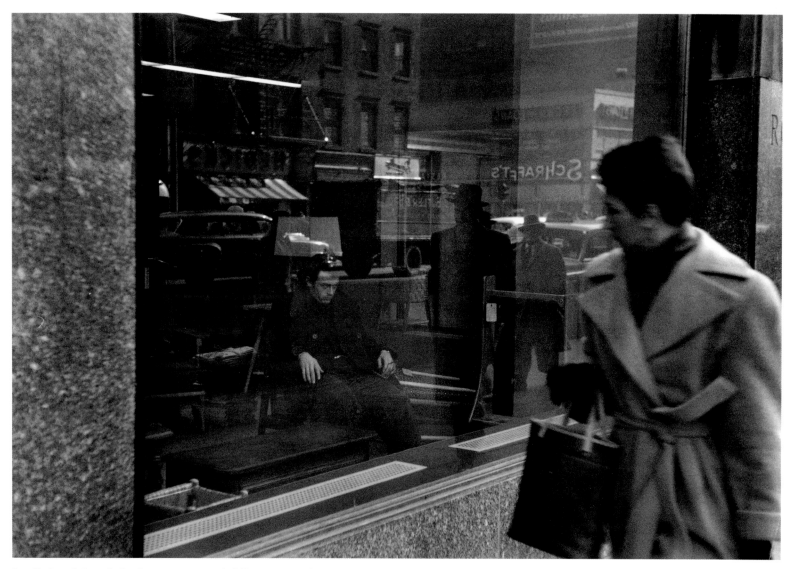

In a display window of a furniture store near Rockefeller Center on 6th Avenue

Im Schaufenster eines Möbelgeschäfts auf der 6th Avenue beim Rockefeller Center

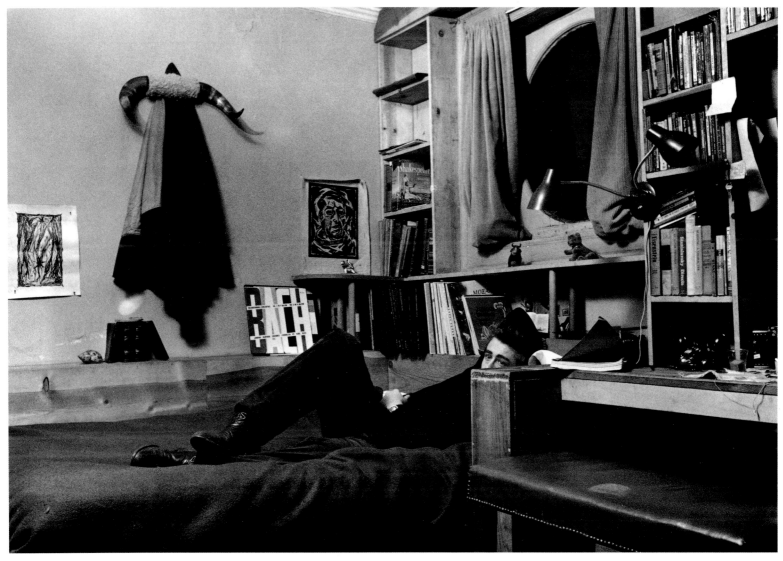

85

In his apartment at West 68th Street, N.Y. In seinem Apartment in der West 68th Street, Manhattan

With a friend at "Jerry's Bar" Mit einer Freundin in »Jerry's Bar«

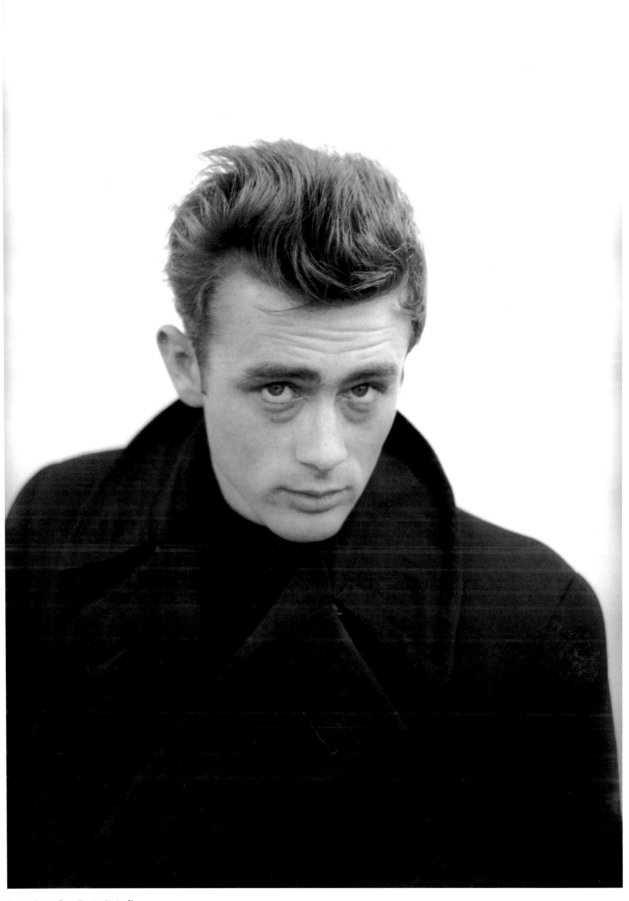

Portrait study Portraitstudie

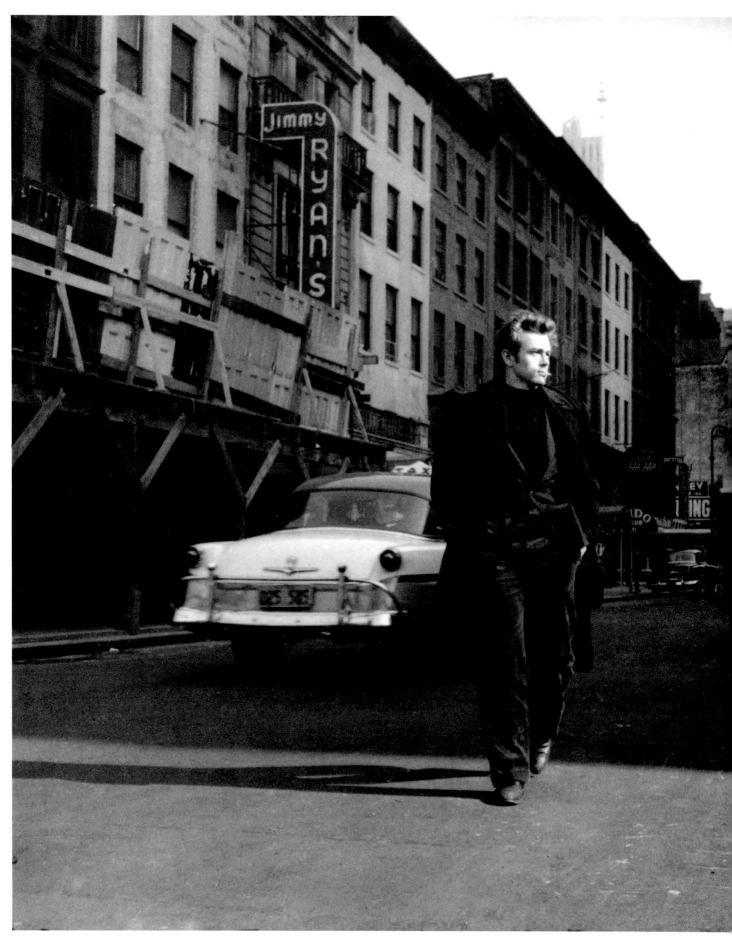

James Dean on 52nd Street in Manhattan Auf der 52nd Street in Manhattan

88

After the success of my photographs of Jimmy Dean, I was frequently assigned to cover films and personalities. Through the fifties and sixties the studios and magazines shipped me around the world. They evidently believed that I saw things differently on the movie set or at the home of their stars. It was all very amusing. My pleasures were more in finding the intimate moments that depicted a less self-conscious side to an actor's character and the offbeat moment behind the scenes on a set rather than what happened in front of a movie camera. The approach toward film makers was no different from that toward any other way of life I encountered: I showed them as real people. Candidness scared the publicity people but getting published was more important so they gave me free rein.

HOLLYWOOD

Nach dem Erfolg meiner Photographien von James Dean wurde ich häufig damit beauftragt, Aufnahmen bei Dreharbeiten zu machen und Filmgrößen abzulichten. Während der fünfziger und sechziger Jahre schickten mich die Studios und Magazine rund um die Welt. Sie glaubten in der Tat, ich hätte einen ganz anderen Blick für die Dinge, wenn ich ihre Stars am Drehort oder zu Hause photographierte. Das war alles sehr amüsant. Ich hatte eine besondere Vorliebe für die intimeren Augenblicke, in denen auch die weniger selbstbewußte Seite der Darsteller zum Vorschein kam. Ich fand das, was sich hinter der Szene abspielte, viel interessanter als das Geschehen vor der Kamera. Bei meiner Arbeit mit den Filmschaffenden verhielt ich mich nicht anders als sonst, ich zeigte sie, wie sie waren, als Privatpersonen. Sich offen zu zeigen fiel den Menschen, die im Rampenlicht standen, schwer, aber beachtet und dargestellt zu werden war wichtiger, also ließen sie mir freie Hand.

Marlon Brando as Napoleon in "Désirée" Marlon Brando als Napoleon in »Désirée«

Director Nicholas Ray Regisseur Nicholas Ray

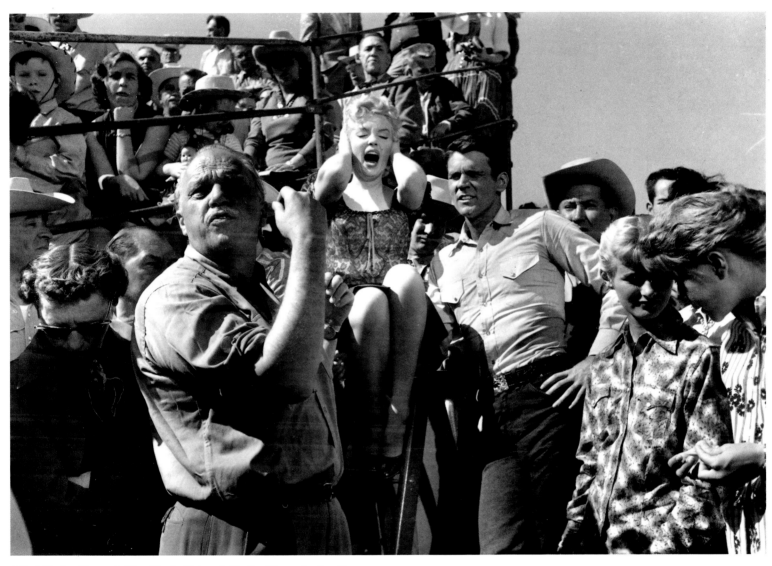

A tired Marilyn Monroe in "Bus Stop" Entnervte Marilyn Monroe in »Bus Stop«

Yves Montand and Simone Signoret at the Academy Awards
Simone Signoret und Yves Montand bei der Oscar-Verleihung

Bing Crosby in 20th Century Fox dining room Bing Crosby in der Kantine der 20th Century Fox

Singer Paul Anka in steam box watching TV Paul Anka im Dampfbad beim Fernsehen

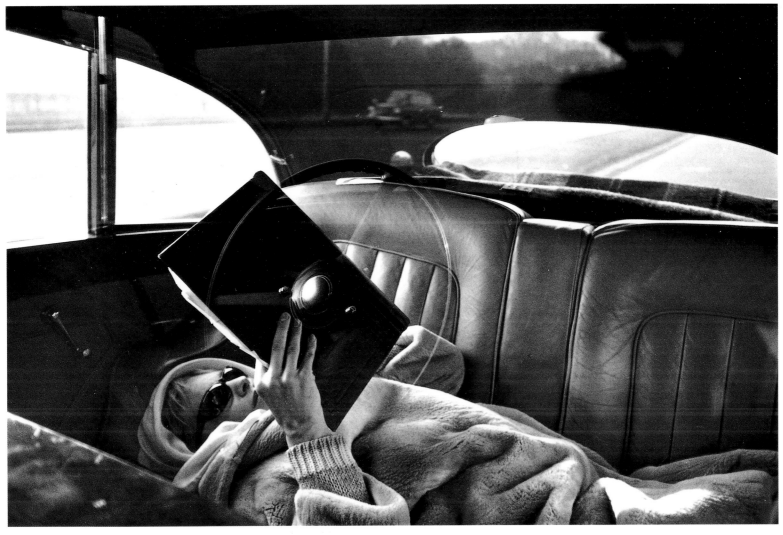

Ingrid Thulin on the way to the studio Ingrid Thulin auf dem Weg ins Filmstudio

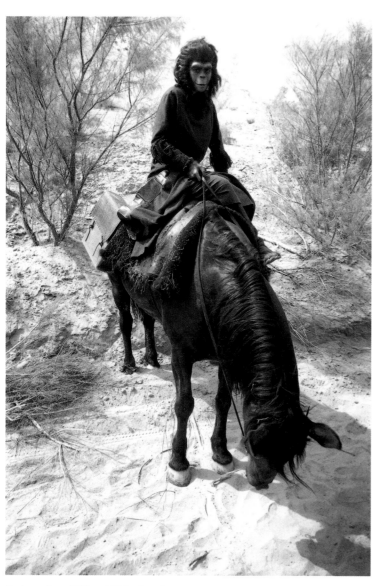

Cast member of "Planet of the Apes"
Darsteller aus »Planet of the Apes«

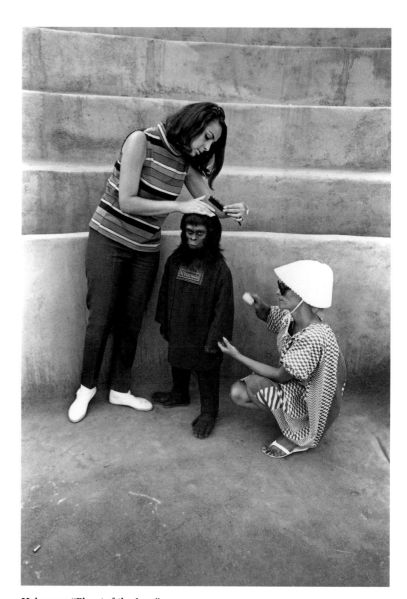

Makeup on "Planet of the Apes"
In der Maske während der Dreharbeiten zu »Planet of the Apes«

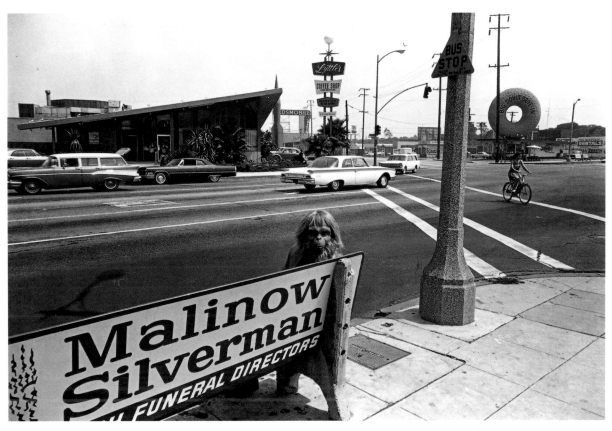

Cast member of "Planet of the Apes" in Los Angeles Darsteller aus »Planet of the Apes«, Los Angeles

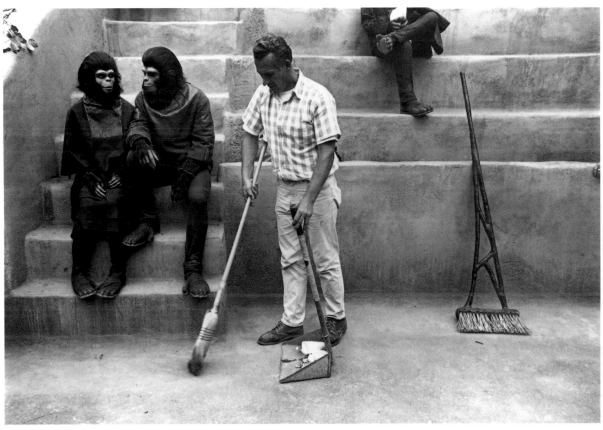

Cast relaxing on set Darsteller während der Drehpause

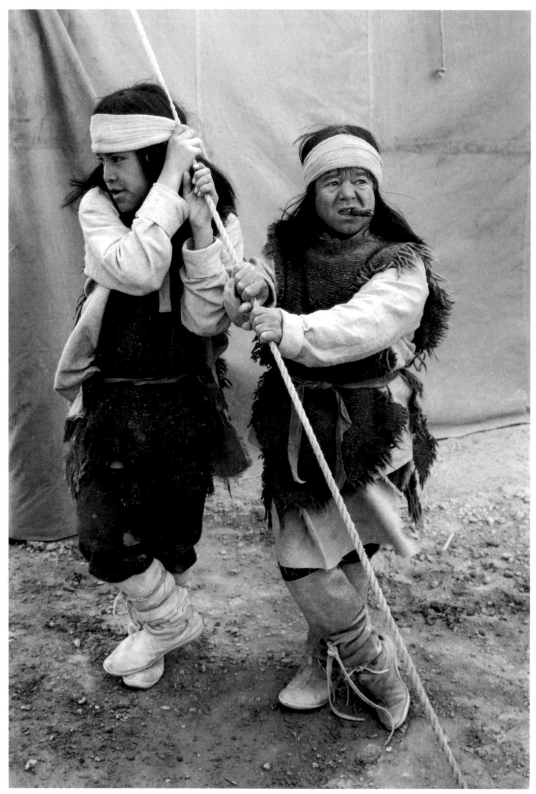

Apache Indian boy and stunt double Apachenjunge und Stunt-Double

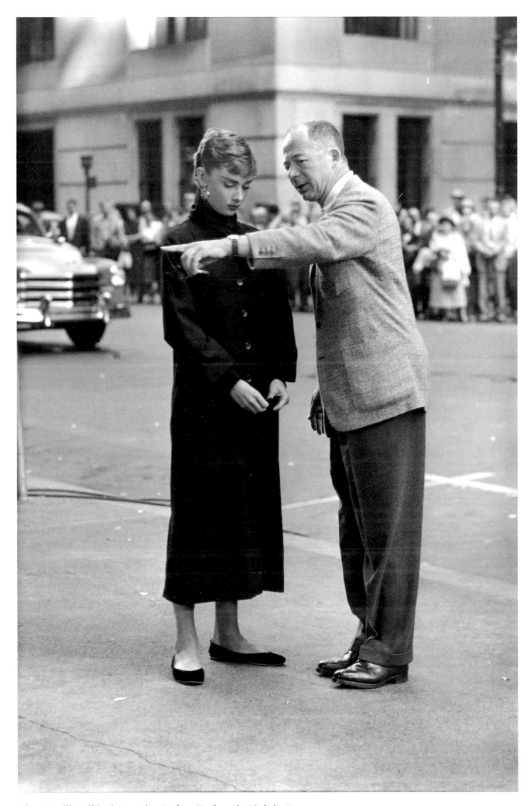

Director Billy Wilder instructing Audrey Hepburn in "Sabrina"
Billy Wilder gibt Audrey Hepburn Regieanweisungen während der Dreharbeiten zu »Sabrina«

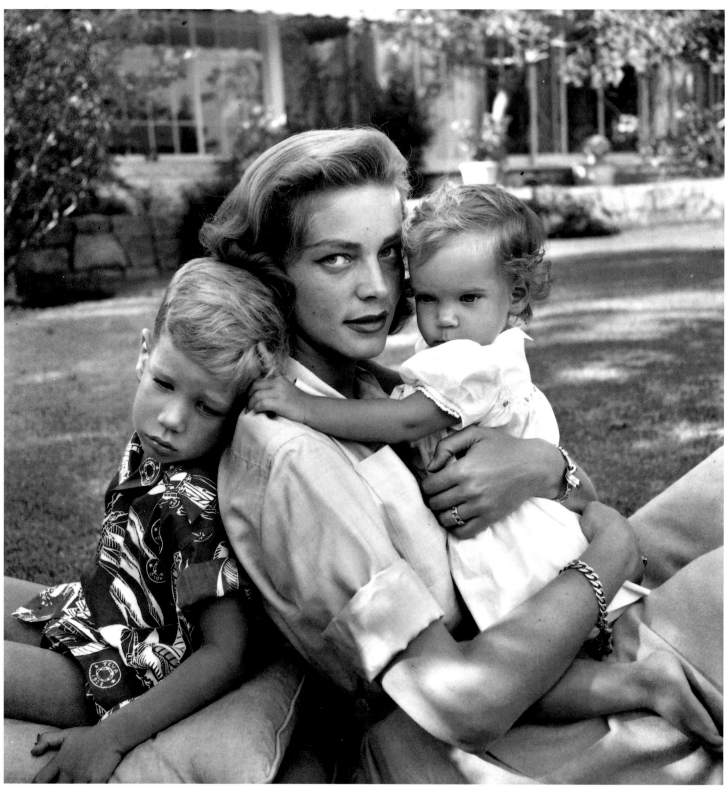

Lauren Bacall (Mrs. Humphrey Bogart) in formal portrait with her children Lauren Bacall (Mrs. Humphrey Bogart) mit ihren Kindern

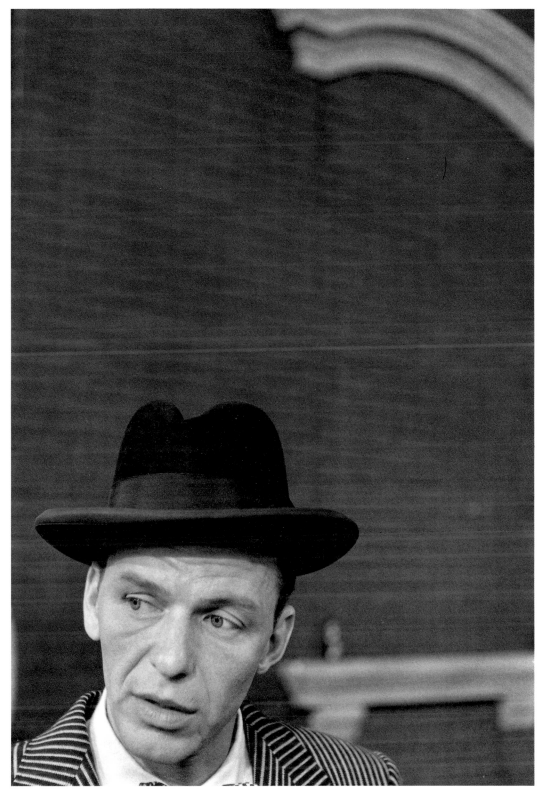

Frank Sinatra in "Guys and Dolls"

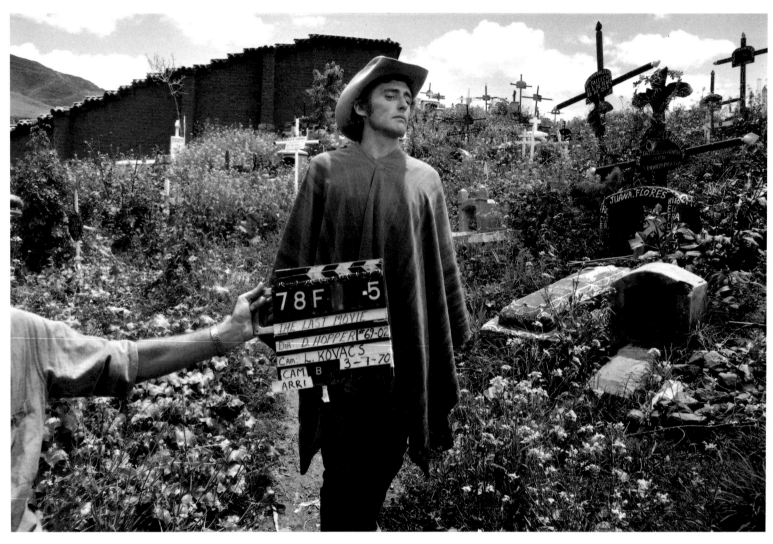

Dennis Hopper in "The Last Movie"

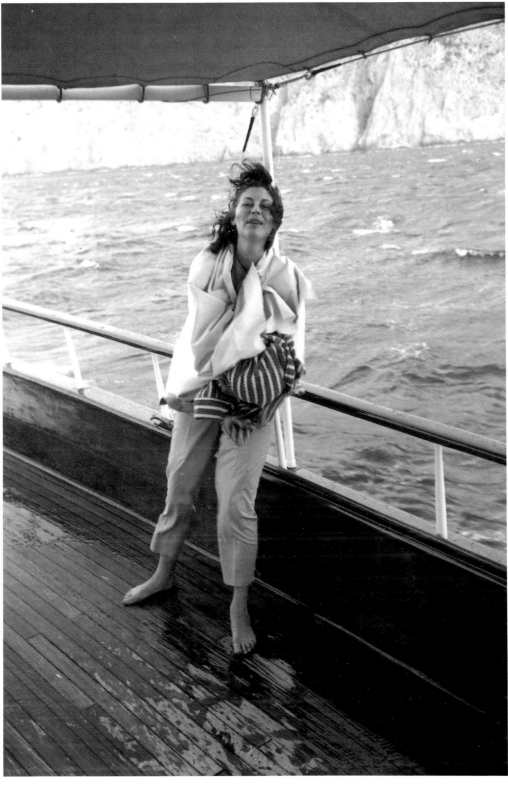

Ava Gardner on vacation Ava Gardner während der Ferien

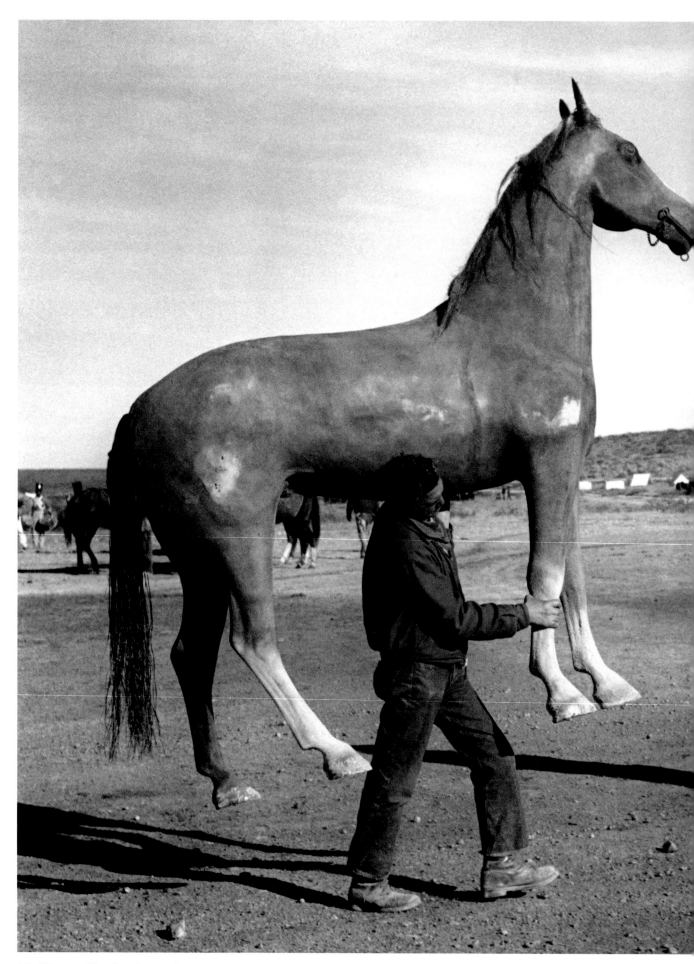

John Wayne on "The Alamo" set John Wayne am Drehort von »The Alamo«

Every year throughout America, the states, counties and towns organize festivals that celebrate many historical events or harvesting times for the nation's farmers. There is often a bizarre atmosphere at the events. For me, these opportunities for Americans to relax and express eccentricities they wouldn't be inclined to do any other time of year reveal how much surrealism is at the heart of the American character. The festivals show our complexity as a nation of driven people in need of a slower and simpler pace or maybe the inevitable emergence of a different species of man. In 1964 and 65, "Holiday" magazine assigned me to tour the country in search of the unexpected; I did.

FESTIVALS

Jedes Jahr veranstalten die einzelnen Staaten, Landkreise und Städte in ganz Amerika Feste, bei denen historische Ereignisse oder Erntedankfeiern für die Farmer des Landes begangen werden.

Es geht dort oft recht bizarr zu. Die Möglichkeit, sich hier einmal richtig gehen zu lassen und alle Extravaganzen hemmungslos auszuleben – etwas, das den meisten den Rest des Jahres kaum einfallen würde – offenbart den surrealistischen Kern, der wohl in jedem Amerikaner steckt. Die Festivals zeigen das Vielschichtige unserer Nation, die sich in ihrer Gehetztheit hin und wieder nach einem gemächlichen und einfachen Leben sehnt, vielleicht kommt dabei aber auch ganz schlicht ein anderer Mensch zum Vorschein. 1964 und 1965 schickte mich die Zeitschrift »Holiday« auf die Reise um das Unerwartete zu suchen. Das habe ich getan.

Crowds awaiting parade in Des Moines, Iowa Parade in Des Moines, Iowa

Beauty contest for cattle, Des Moines Schönheitswettbewerb für Rinder, Des Moines

Beauty contest for cattle, Des Moines Schönheitswettbewerb für Rinder, Des Moines

Archery contestant Wettbewerb im Bogenschießen

Indian powwow Stammestreffen

Iowa fair Auf einem Volksfest in Iowa

Los Angeles parade Parade in Los Angeles

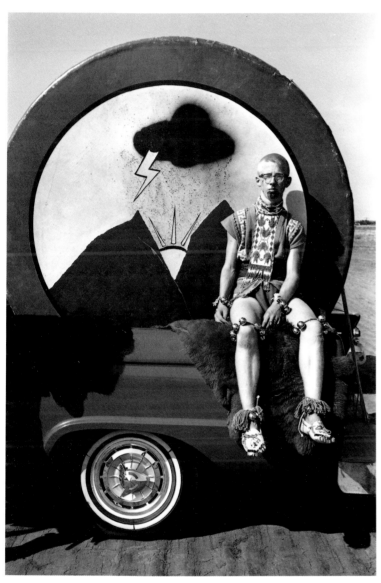

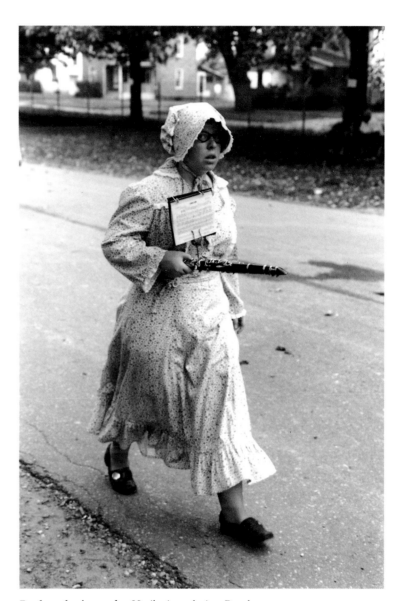

Oklahoma fair Auf einem Volksfest in Oklahoma

Band member in parade Musikerin nach einer Parade

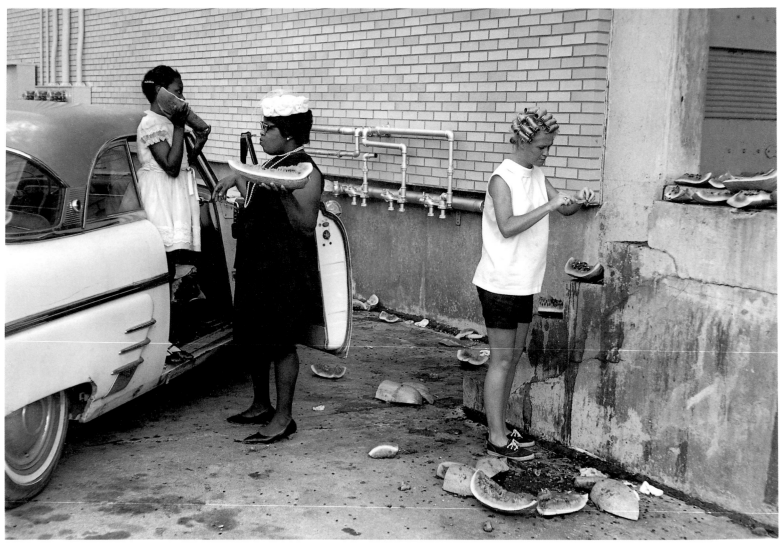

Atlanta water melon festival Wassermelonenfest in Atlanta

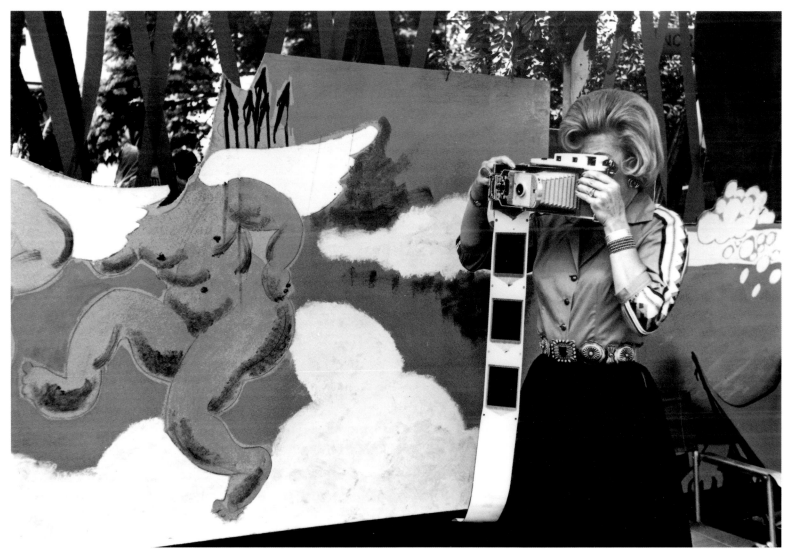

Santa Fe fair, photography concession Jahrmarktphotographin auf einem Volksfest in Santa Fe, New Mexico

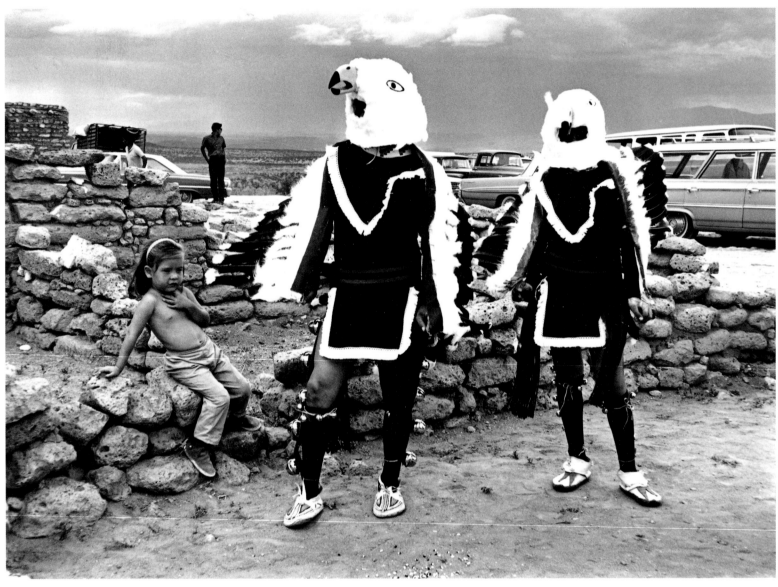

Taos, New Mexico, Indian festival Indianisches Volksfest, Taos, New Mexico

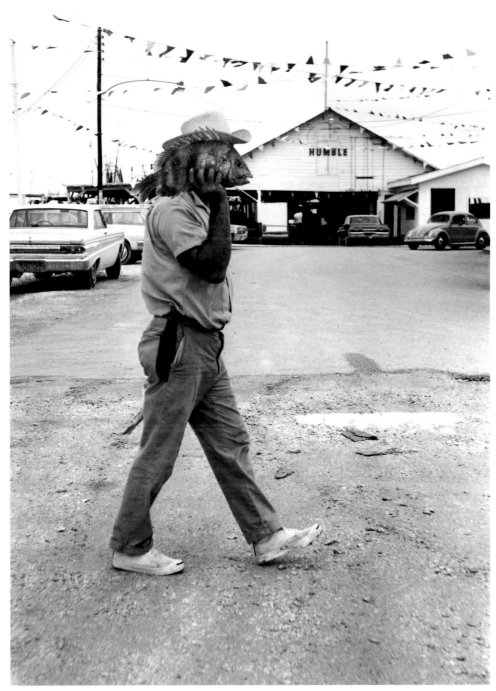

Fishermen's gathering, Grand Isle, Louisiana Fest der Fischer, Grand Isle, Louisiana

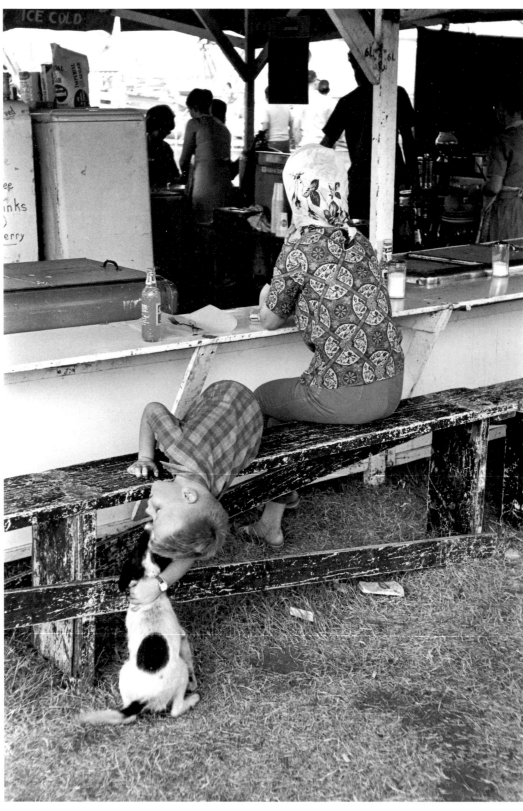

Dallas state fair Volksfest in Dallas, Texas

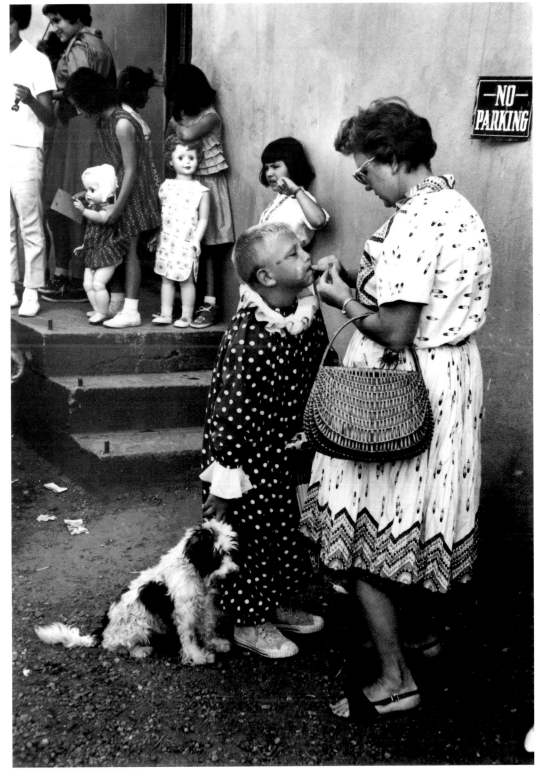

Santa Fe county fair Volksfest in Santa Fe, New Mexico

Father and sons, Dallas state fair Vater und Söhne auf einem Volksfest in Dallas, Texas

There is no question that the Americans are vagabonds. Our highway system and size makes it very attractive to "truck on down." On the average, we change homes five times in a lifetime, moving from one end of the nation to the other. Many of us take to the road in motorhomes, trailers, on motorcycles or by hitch-hiking. This itch to see "what is over the hill," is something that I can easily relate to as a photographer. The restlessness of Americans is found at the campgrounds and byways, where the brief stays and instant comradeship reveal plans for distant places and a kindness towards their fellow travelers that is less frequent back home. The Americans will always seek a better place. This essay was self-assigned and photographed throughout the year of 1971.

ON THE ROAD

Amerikaner sind zweifellos Vagabunden. Unsere Highways verführen geradezu zum »truck on down«. Durchschnittlich wechseln wir fünf-mal unseren Wohnsitz und lassen dabei riesige Strecken hinter uns, indem wir vom einen Ende der Staaten zum anderen ziehen. Viele von uns bewegen sich mit Wohnmobil oder Wohnwagen, Motorrad oder per Anhalter fort. Dieses Prickeln, zu erfahren, was sich hinter der nächsten Ecke verbirgt, ist mir als Photographen sehr vertraut. Das Rastlose der Amerikaner zeigt sich auf Campingplätzen und Nebenstraßen, wo man während kurzer Aufenthalte sofort Kameradschaft schließt, über entlegene Ziele plaudert und dem anderen Reisenden gegenüber eine Freundlichkeit an den Tag legt, der man zuhause nicht so häufig begegnet. Amerikaner sind immer auf der Suche nach einem noch angenehmeren Aufenthaltsort. Dieses Photoessay entstand während des Jahres 1971 »im eigenen Auftrag«.

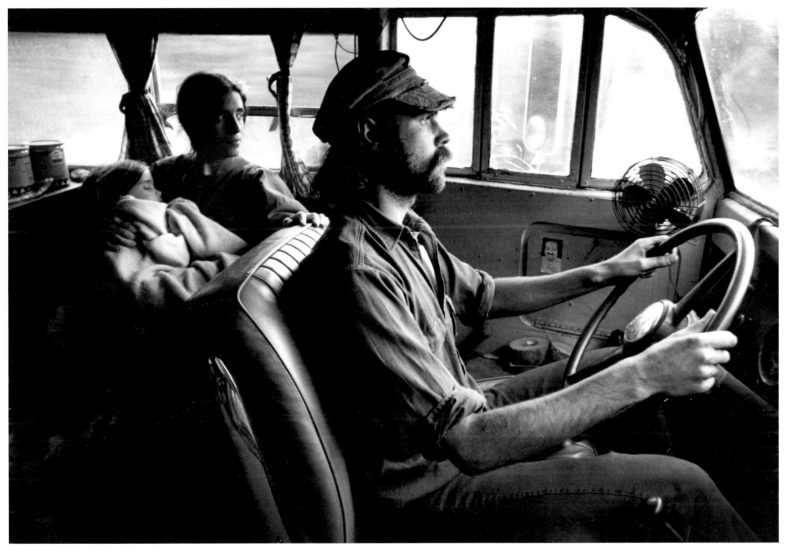

A family of three lives in an old school bus converted to a motorhome Dreiköpfige Familie unterwegs im Wohnmobil, einem umgebauten Schulbus

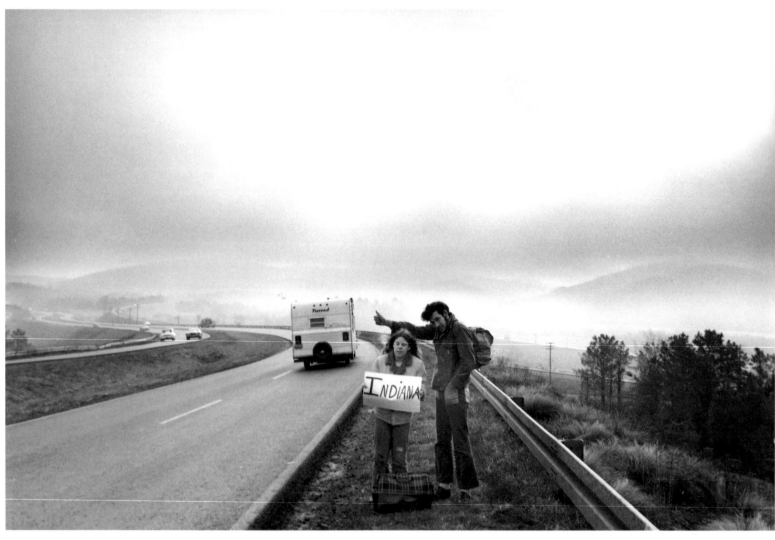

Young hitchhikers on the way to Indiana Junge Tramper auf dem Weg nach Indiana

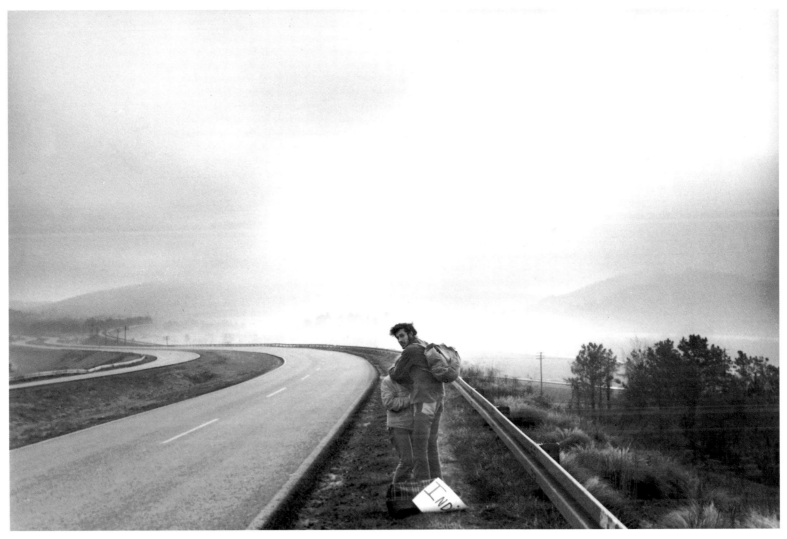

Young hitchhikers windswept and ignored Junge Tramper im Regen stehengelassen

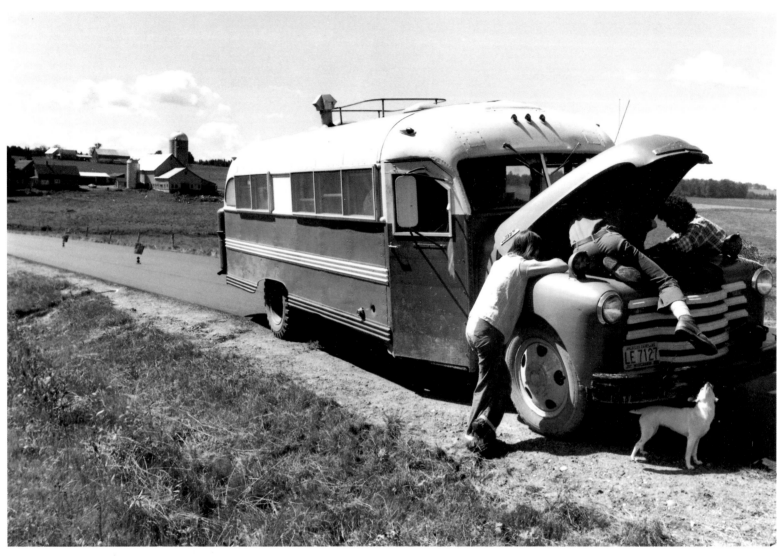

An undeliberate stop Unfreiwilliger Aufenthalt

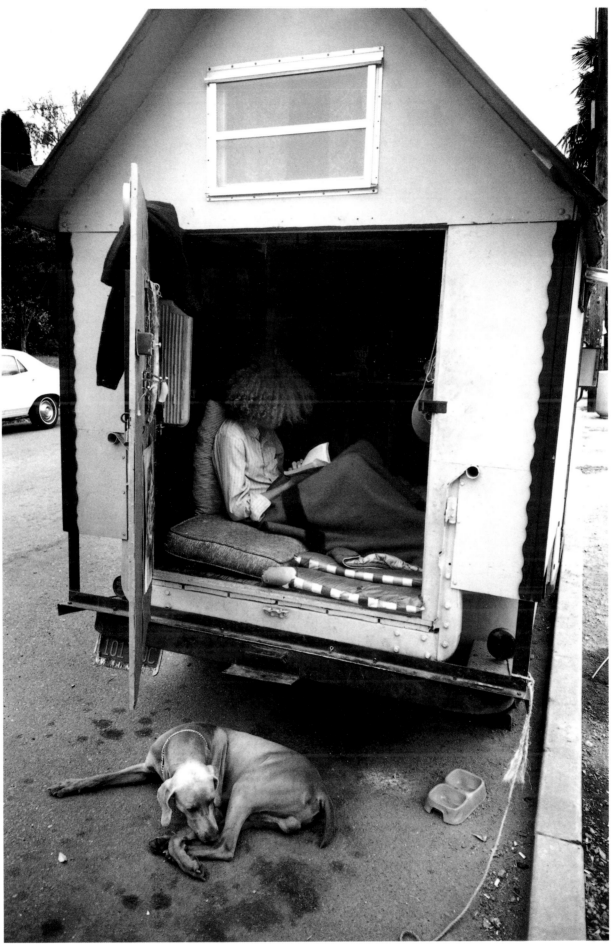

A house on wheels parked on suburban streets Haus auf Rädern in einem Vorort

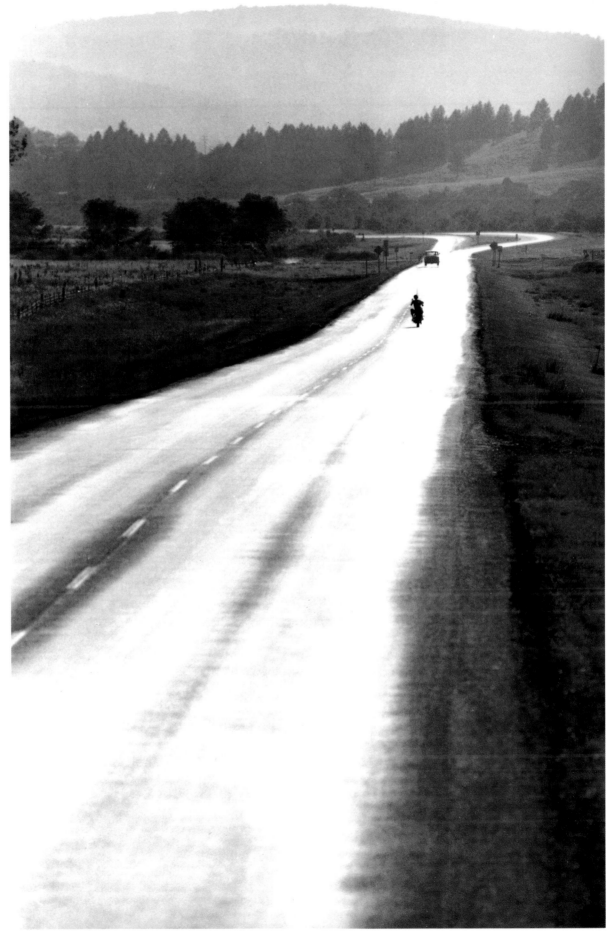

The open road for a biker Die Freiheit der Landstraße

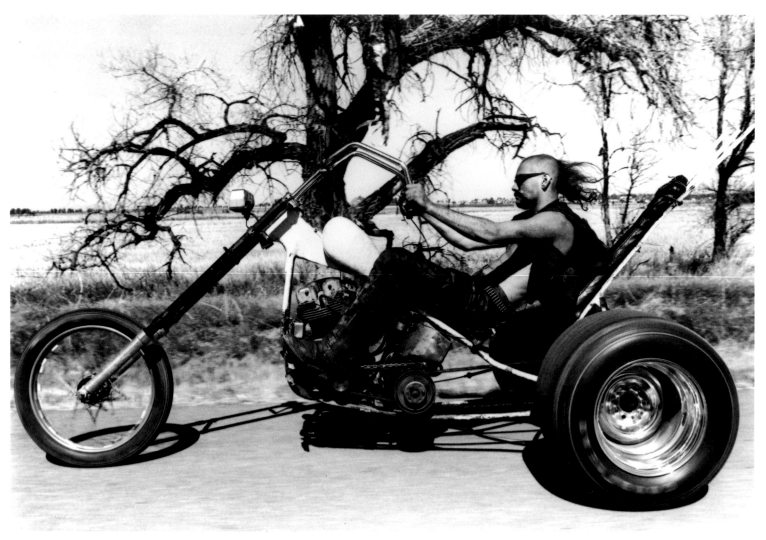

Biker in the popular "mongol" look Biker im populären »Mongolenlook«

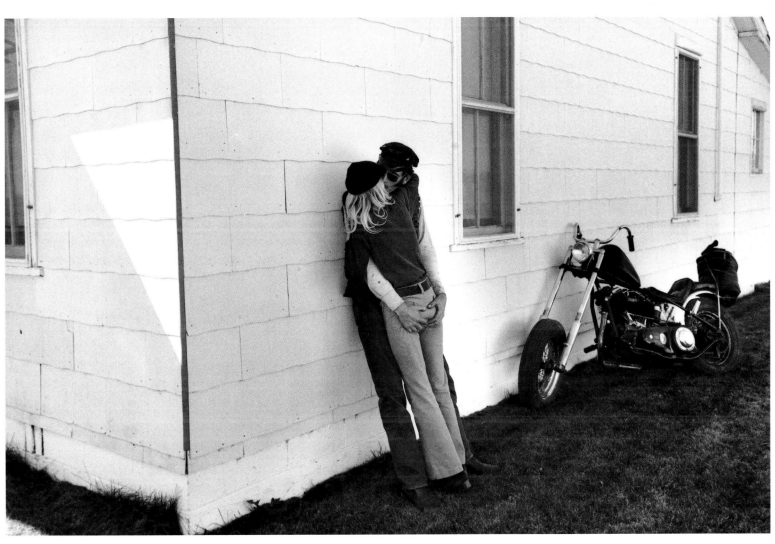

Making "it"

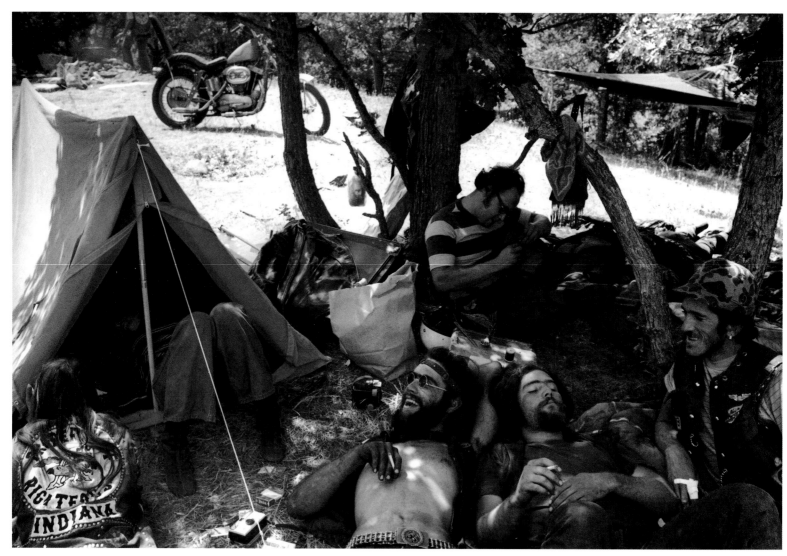

The bikers camp out Biker am Lagerplatz

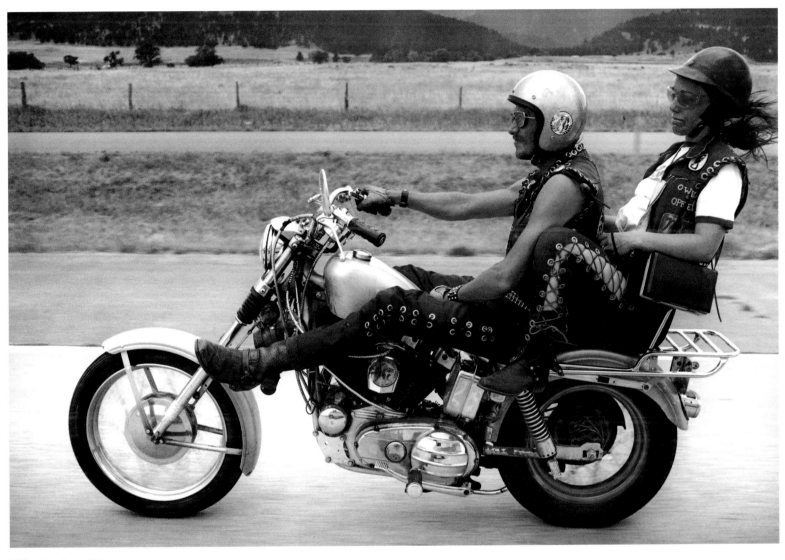

Riding together Unterwegs

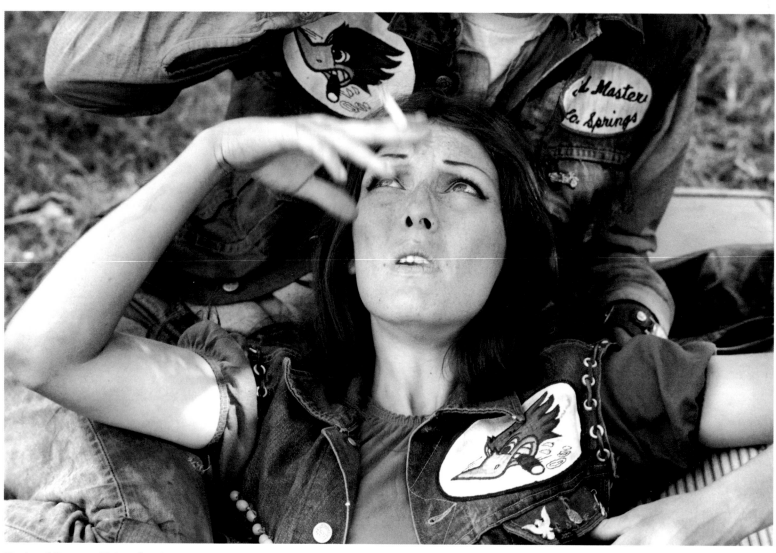

Member of the gang Motorradbraut

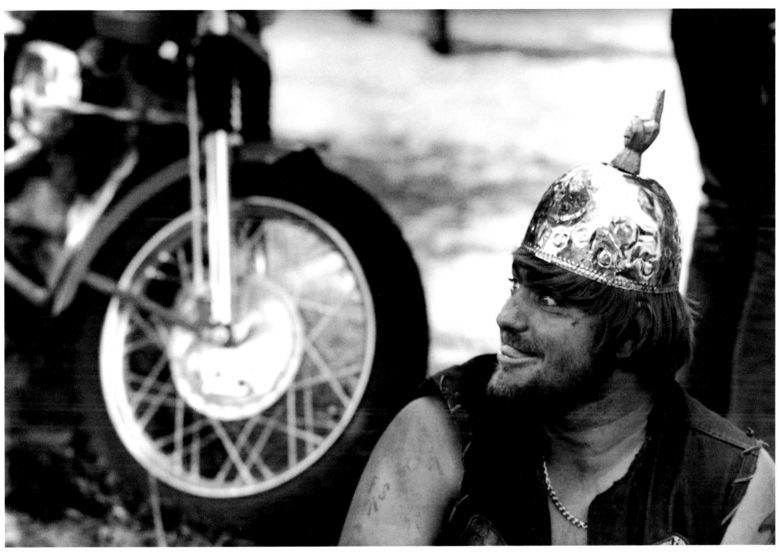

A "wild one"

138

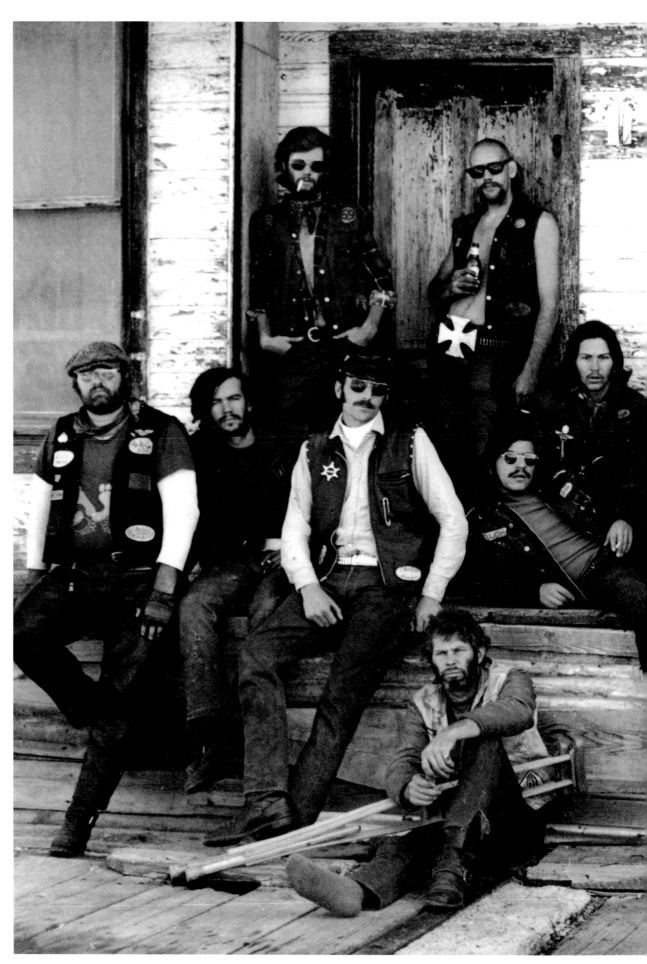

The Colorado bikers club "Sons of Silence" »Sons of Silence«, Bikergang, Colorado

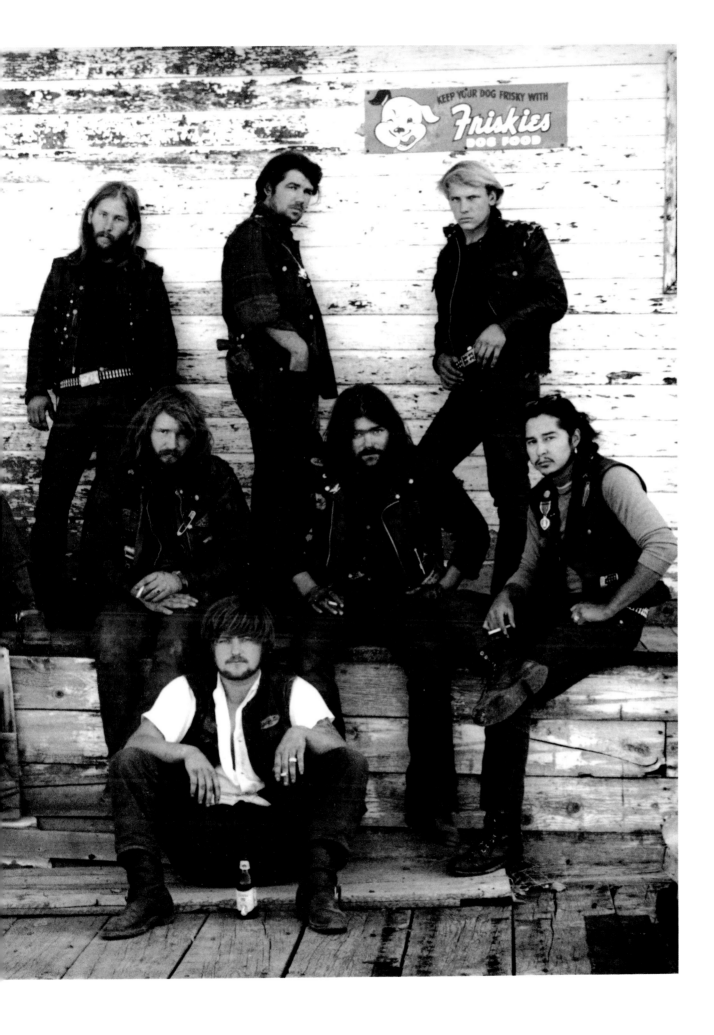

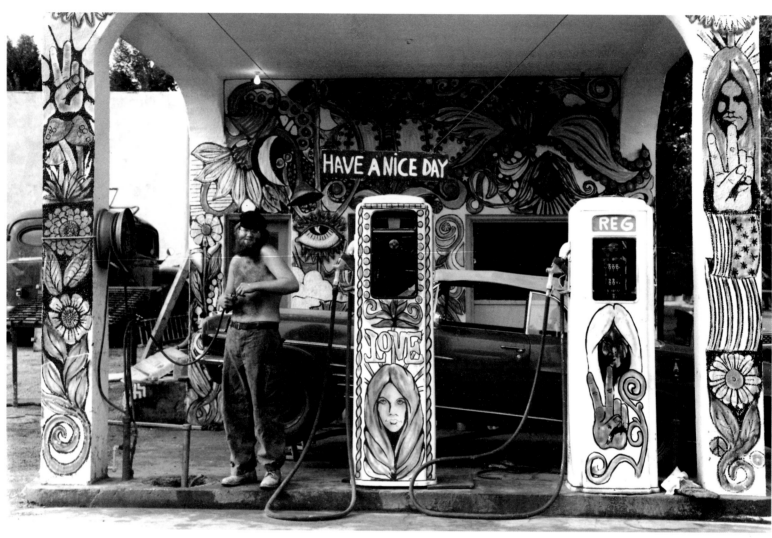

Hippie gas station Hippie-Tankstelle

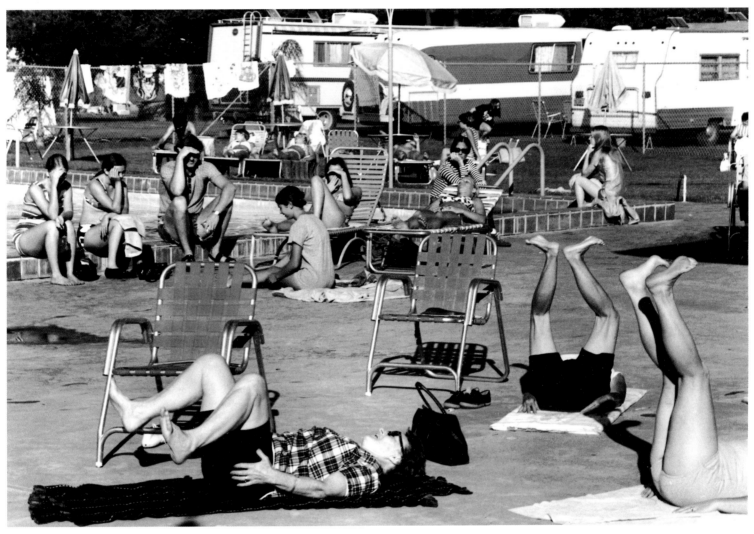

Exercise class at campground in Florida Gymnastik auf einem Campingplatz in Florida

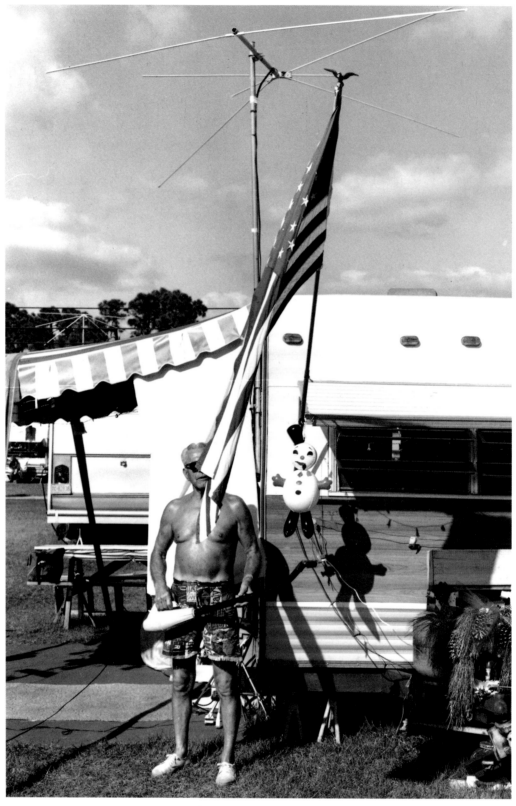

Retirees paradise at a Florida campground Rentnerparadies auf einem Campingplatz in Florida

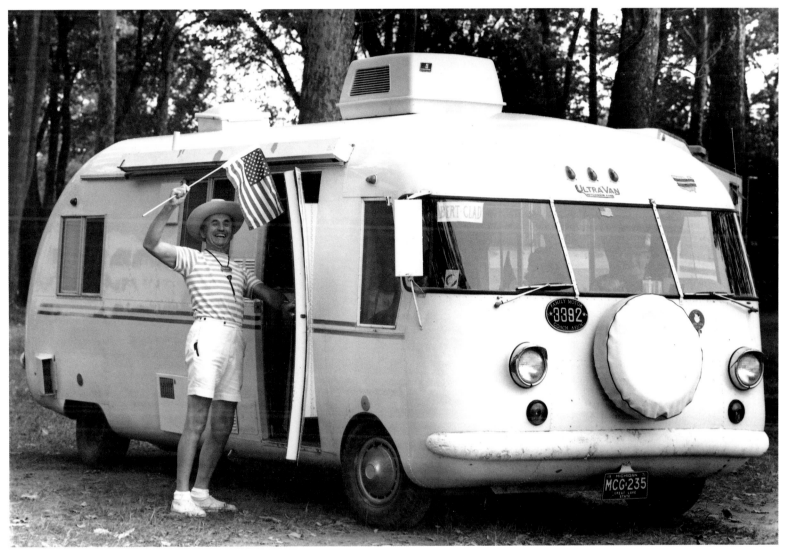

A proud American with his space mobile Stolzer Amerikaner vor seinem Wohnmobil

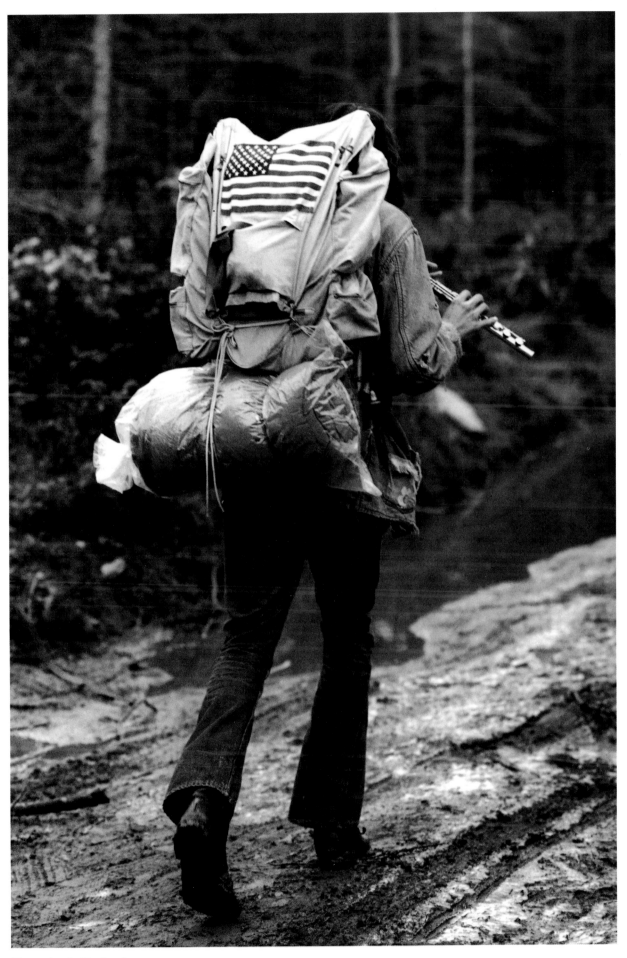

The vagabond Vagabund

In the latter half of the sixties a generation with an energy and vision appeared on the horizon – a dramatic force that brought the American conservative scene to a halt. The young decided to take destiny into their own hands and shape a future of love and caring. Many groups formed communes throughout the nation. I felt compelled to visit and photograph the lifestyles of these young people as they sought a better world. My coverage explored the settlements in New Mexico, Vermont and California. The result was a book, "The Alternative," photographed in 1969 and published in 1970.

HIPPIES

In den späten sechziger Jahren machte eine Generation von sich reden, die mit ihren Visionen und einem ungezügelten, fast dramatischen Durchsetzungswillen das konservative Amerika aufhorchen ließ. Diese jungen Menschen wollten ihr Leben selbst in die Hand nehmen und stellten sich eine Zukunft vor, die von Liebe und Respekt geprägt war. Viele Gruppen bauten damals überall Kommunen auf. Ich wollte diese Leute mit ihrer Sehnsucht nach einer besseren Welt unbedingt besuchen und ihre Art zu leben dokumentieren. Ich photographierte Kommunen in New Mexico, Vermont und Kalifornien. Daraus entstand das Buch »The Alternative« mit Photos von 1969. Es erschien 1970.

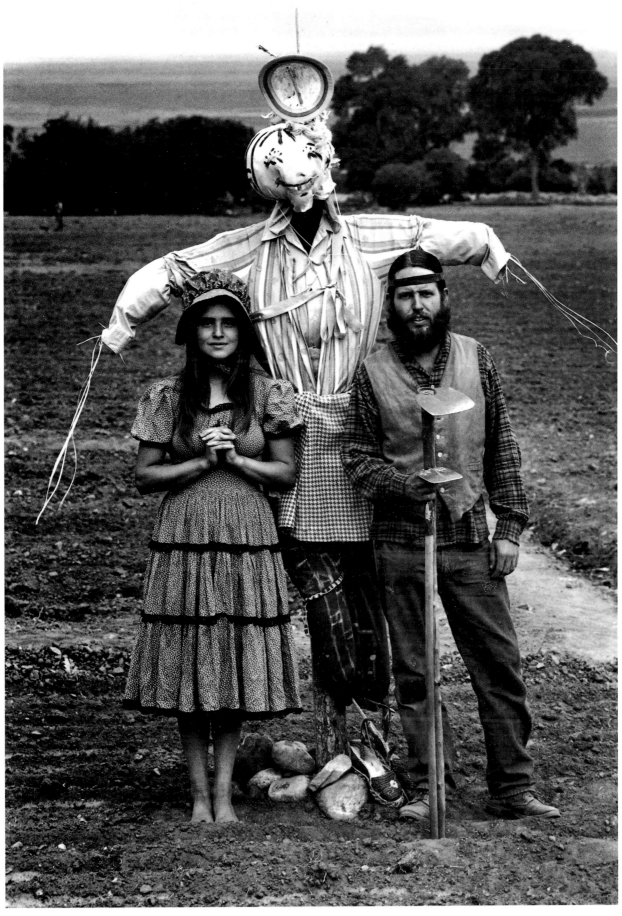

Portrait of a couple in "American Gothic style" Frei nach Grant Wood, »American Gothic«

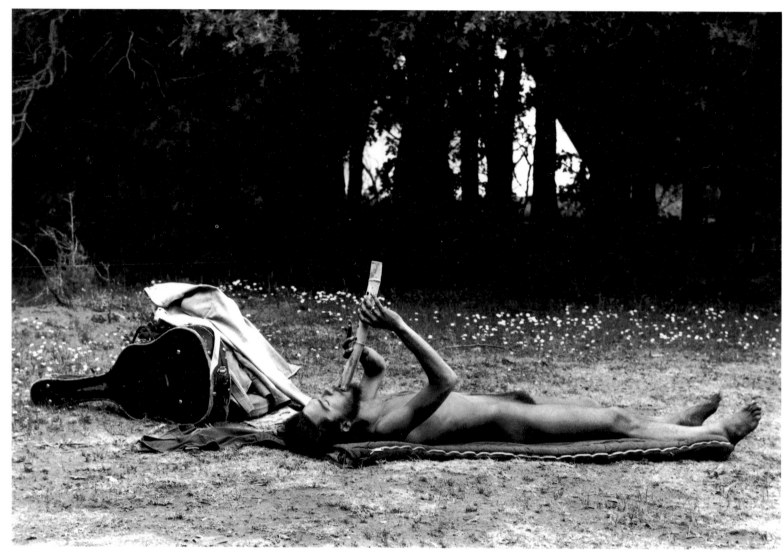

Hippie at "New Buffalo" commune, New Mexico Ein Hippie in der »New Buffalo«-Kommune, New Mexico

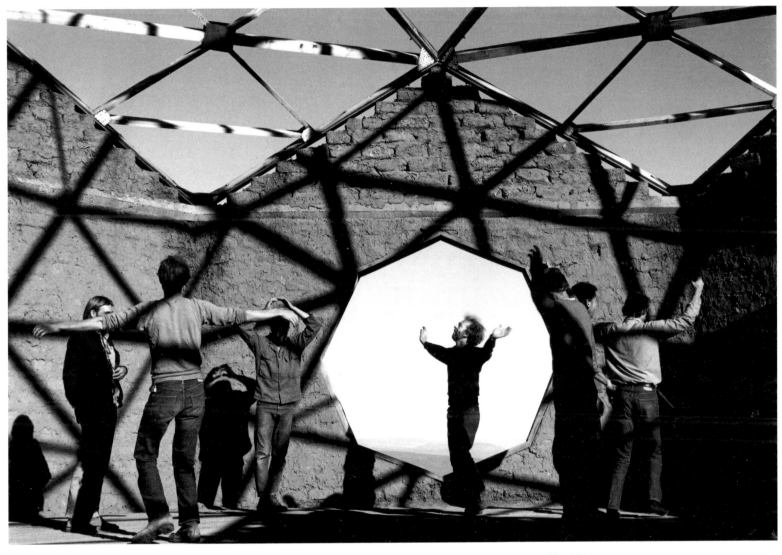

Spiritual dancing during construction at "Lama," New Mexico Spiritueller Tanz bei Bauarbeiten in der »Lama«-Kommune, New Mexico

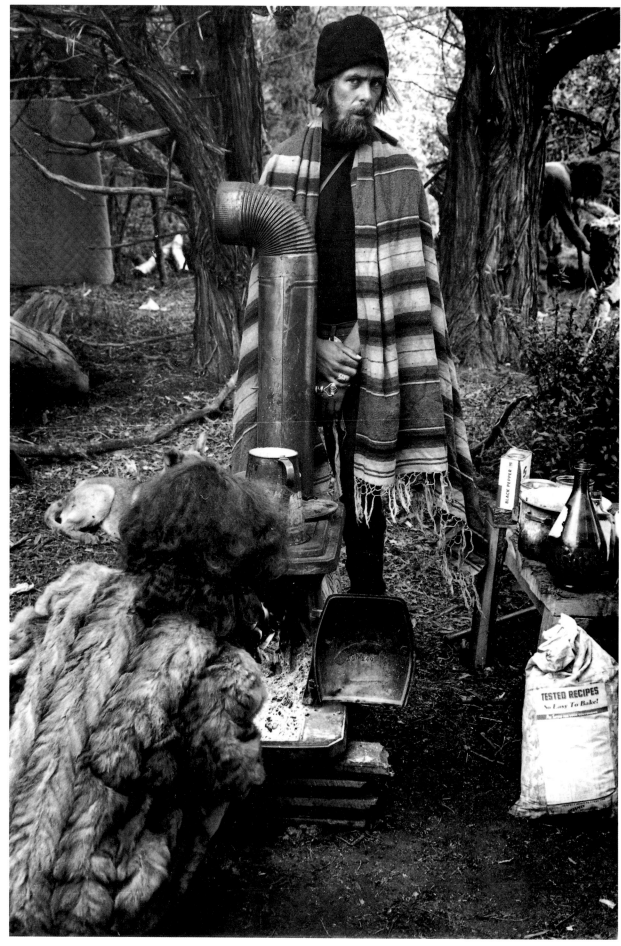

Living by the fundamentals at "New Buffalo," New Mexico Das einfache Leben in der »New-Buffalo«-Kommune, New Mexico

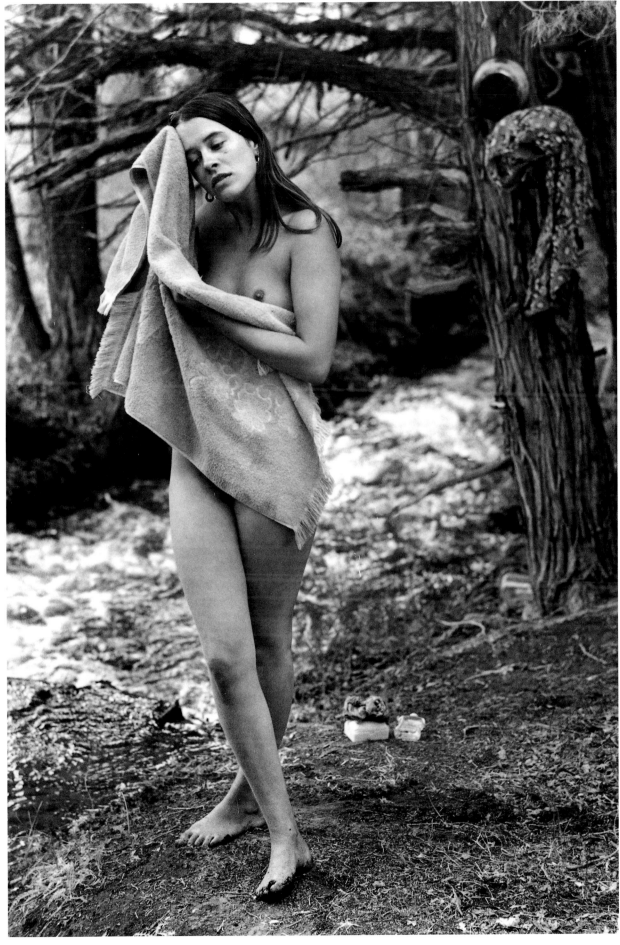

The morning bath Das Bad am Morgen

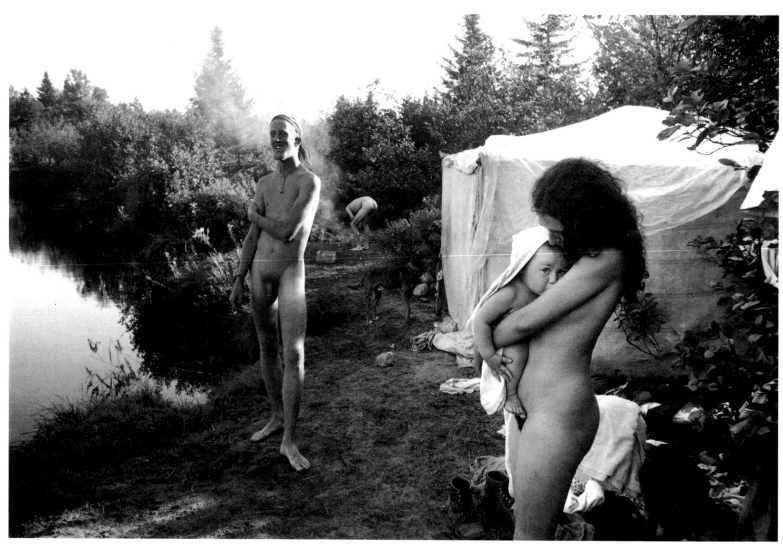

Vermont commune Kommune in Vermont

Meditation in San Francisco commune Meditation in einer Kommune in San Francisco

Resting in New Mexico In einer Kommune in New Mexico

154

At a California commune In einer Kommune in Kalifornien

At the "Lorien" commune, fields are cleared and seed planted Feldarbeit in der »Lorien«-Kommune

Seeding Bei der Aussaat

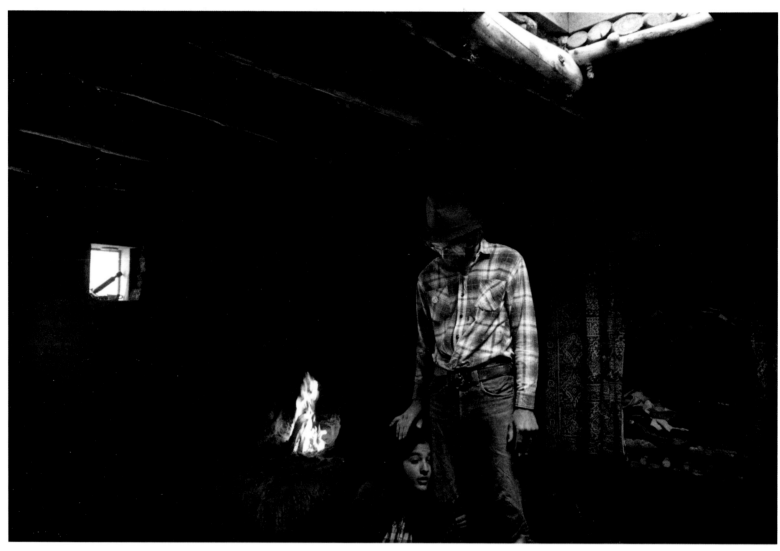

A couple at "New Buffalo" commune In der »New Buffalo«-Kommune, New Mexico

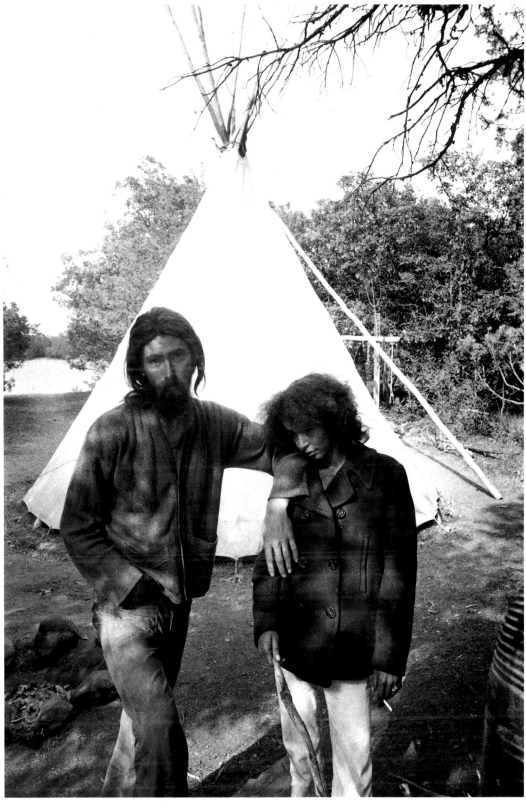

The fatigue of a harsh life Hartes Leben in der Kommune

This is the preface I wrote in 1968 to accompany the book "California Trip." All photographs were taken in 1968.

For many years California frightened me; the contrasting arenas of life shook me up. Even though I found the sun and the fog, sand and sierras which conveyed a firm image of stark reality, the mother vision of life, the state seemed unreal. The people were constructing layers and dimensions of life that unsettled me. Surrealism was everywhere, the juxtaposition of relative levels of reality projected chaos. For the young man with traditional concerns for a spiritual and aesthetic order, California seemed too unreal; I ran.

Fifteen years since my first trip west, I have some new thoughts about Gloryville. Every idea that Western man explores in his pursuit of the best of all possible worlds will be searched at the "head lab" in California. Technological and spiritual quests vibrate throughout the state, intermingling, often creating the ethereal. It is from this freewheeling potpourri of search that the momentary ensembles in space spring, presenting to the photographer his surrealistic image. However, to the Californians it is all so ordinary, almost mundane. The sensibility of these conditioned victims is where it is all at, right, left, up and down. Our future is being determined in the lab out west. There, a recent trip blew my mind across this state of being, as I collected images along the way to remember the transient quality of the big trip.

C A L I F O R N I A

Das folgende Vorwort habe ich 1968 für das Buch »California Trip« verfaßt. Sämtliche Photos wurden 1968 aufgenommen.

Jahrelang war mir Kalifornien unheimlich. Die scharfen Kontraste des Lebens dort haben mich verwirrt. Auch wenn es Sonne und Nebel gab, Sand und die Sierra, die das klare Bild einer überdeutlichen Realität vermittelten, schienen mir die allgemeine Lebensauffassung und der Staat selbst unwirklich. Die Menschen hatten sich hier Lebensformen konstruiert, die mir äußerst unbehaglich waren. Alles schien irgendwie surreal, das Nebeneinander verschiedener Realitätsebenen war chaotisch. Für mich als junger Mann mit traditionellen geistigen und ästhetischen Prinzipien war Kalifornien einfach zu unwirklich. Ich floh.

Fünfzehn Jahre nach meiner ersten Reise in den Westen hat sich meine Haltung zu Gloryville etwas gewandelt. Jedem Traum, den jemand aus dem Westen auf der Suche nach der besten aller möglichen Welten träumt, wird hier im »head lab«, in Kalifornien, nachgejagt. Allenthalben ist die Rede von Technologie und Spiritualität, und beides wird oft völlig abgehoben miteinander vermischt. Dieses fluktuierende Potpourri von Sinnsuchenden läßt die Atmosphäre von Gruppenbewußtsein im Augenblick geradezu überquellen und präsentiert sich dem photographischen Auge in all seiner Surrealität. Für die Leute in Kalifornien selbst ist das alles völlig normal und ganz von dieser Welt. Die Sensibilität dieser konditionierten Opfer umschwebt einen wo man geht und steht. Unsere Zukunft scheint ganz vom »lab out west« abzuhängen. Auf meiner letzten Reise kam mir dies in aller Deutlichkeit zum Bewußtsein, während ich unterwegs Bilder machte, die mich einst an das Flüchtige des großen Trips erinnern sollten.

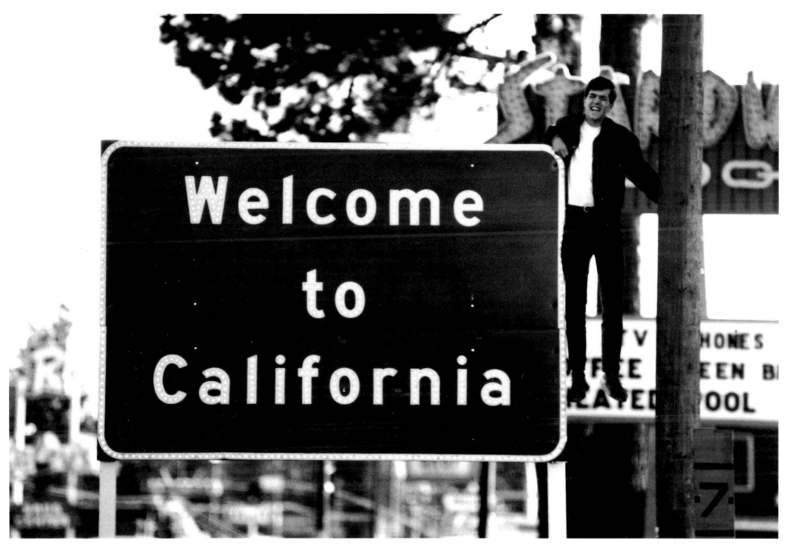

State border at Lake Tahoe Staatsgrenze zwischen Nevada und Kalifornien am Lake Tahoe

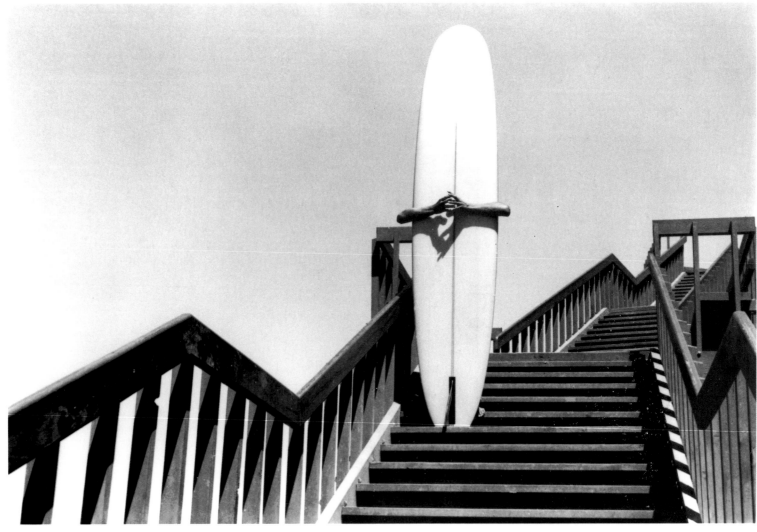

Surfer at Corona de Mar Surfer in Corona de Mar

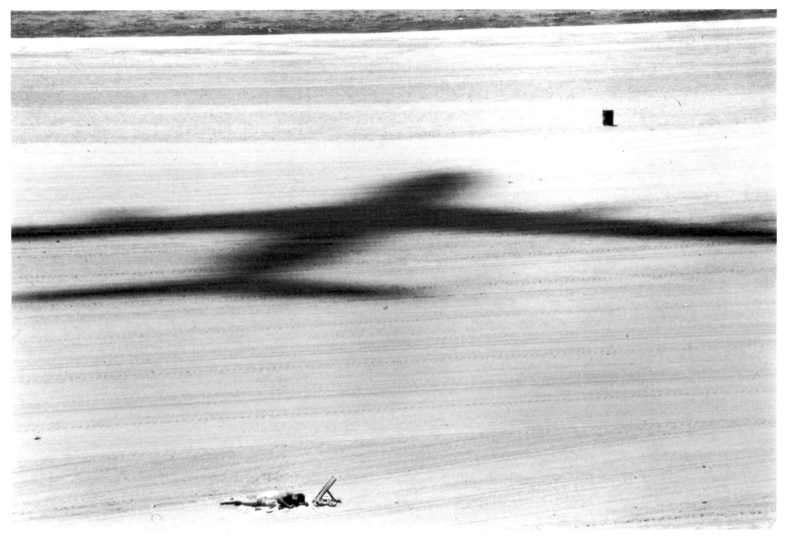

"Playa del Ray" beach bordering L.A. airport Am Strand »Playa del Ray« nahe dem Flughafen von Los Angeles

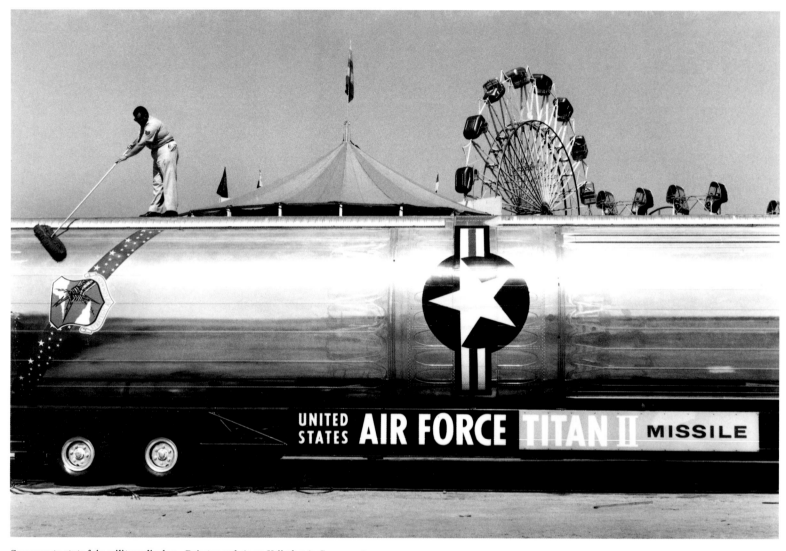

UNITED STATES **AIR FORCE** TITAN II MISSILE

Sacramento state fair, military display Raketen auf einem Volksfest in Sacramento

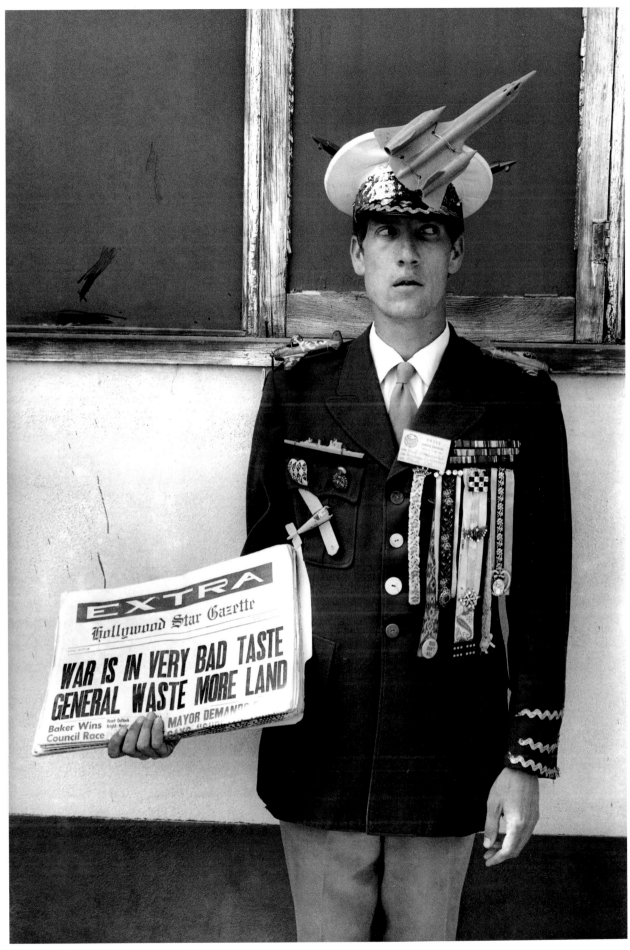

Pacifist demonstrating at Santa Monica Pazifist, Santa Monica

Oldtimers day at Cannery Row, Monterey Oldtimer-Treffen, Cannery Row, Monterey

Missile parts laundry personnel, Vandenberg Air Base Reinigungspersonal für Raketen, Vandenberg Air Base

Posing for publicity Publicitygag am Strand

Berkeley Campus Auf dem Campus der Universität von Berkeley

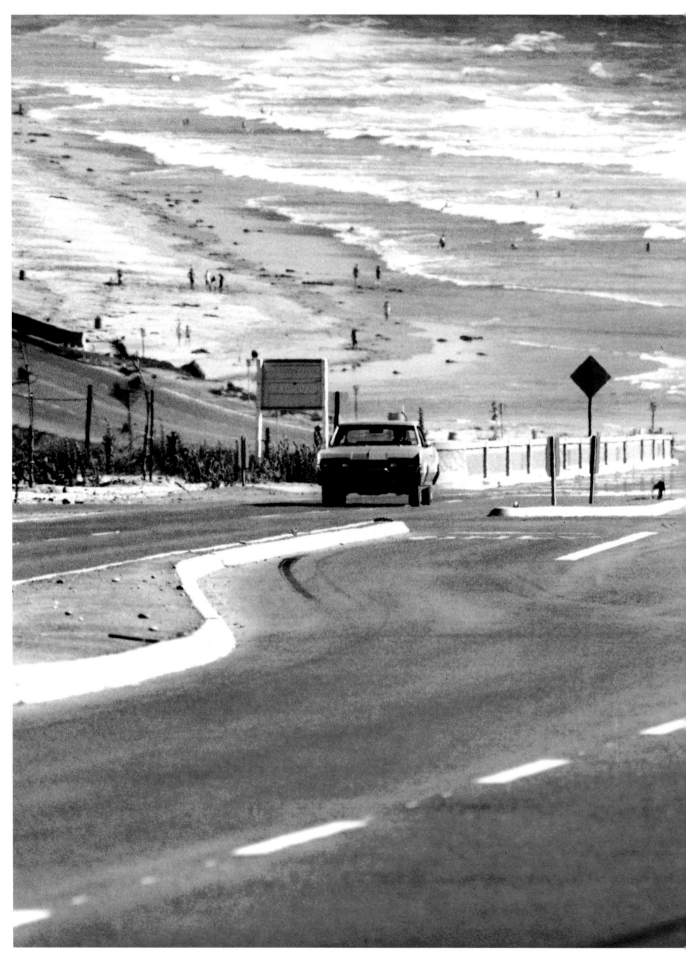

San Diego coastline Küstenstraße bei San Diego

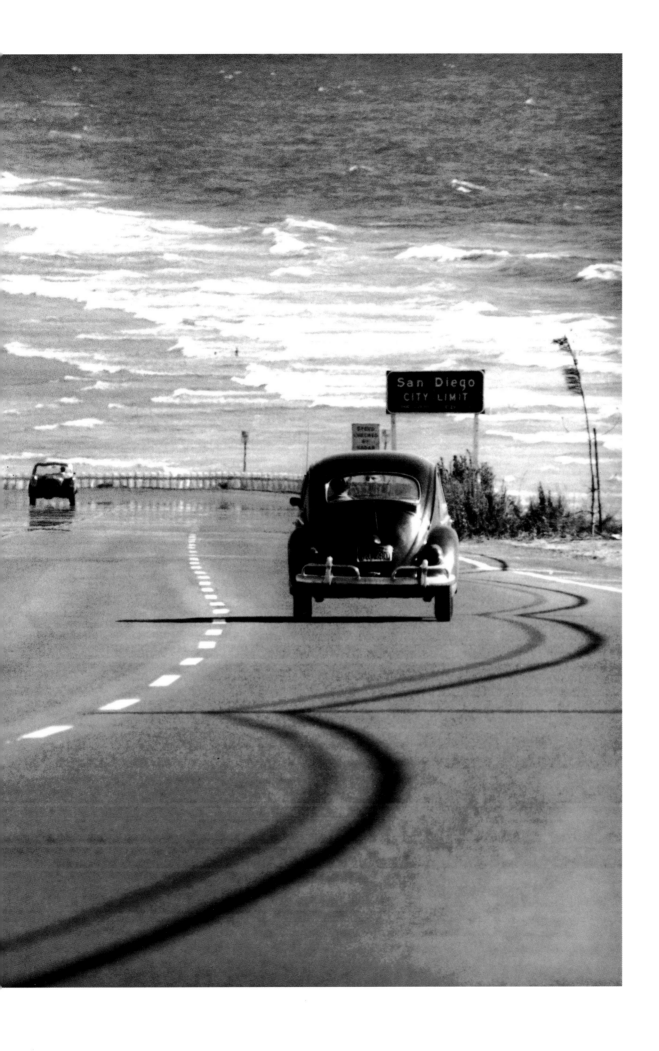

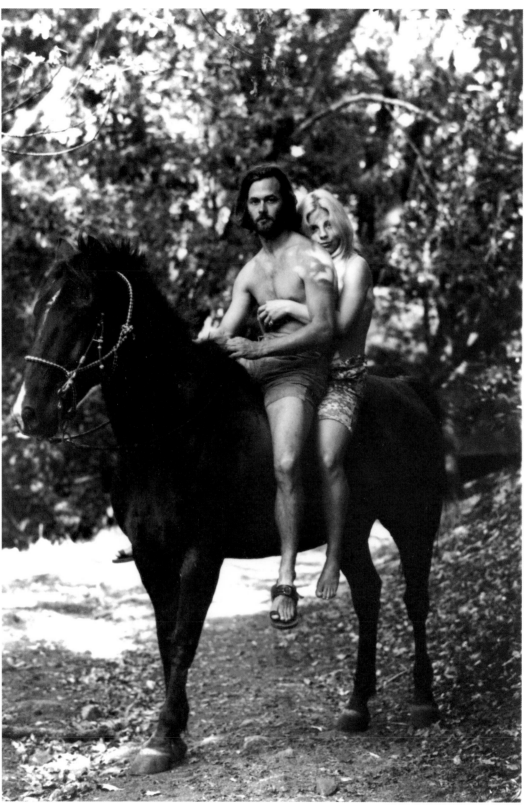

Couple in Novato Pärchen in Novato

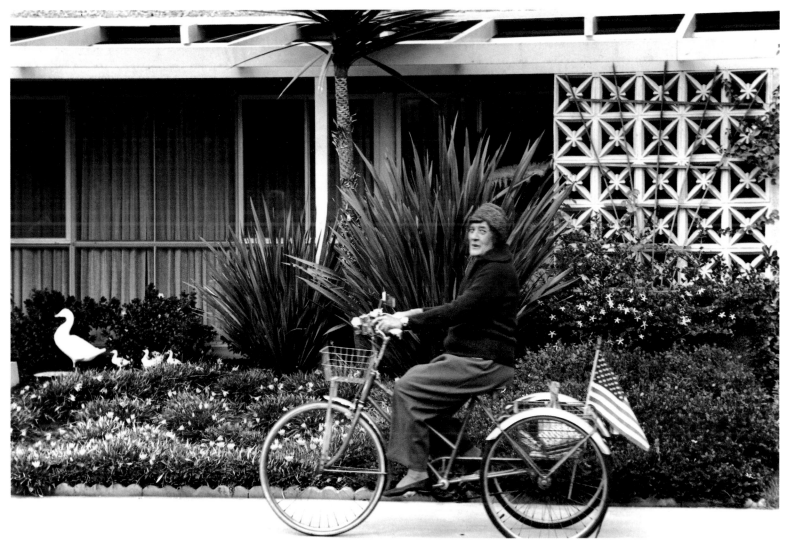

At "Leisure World," retirement community In »Leisure World«, einer Siedlung für Rentner

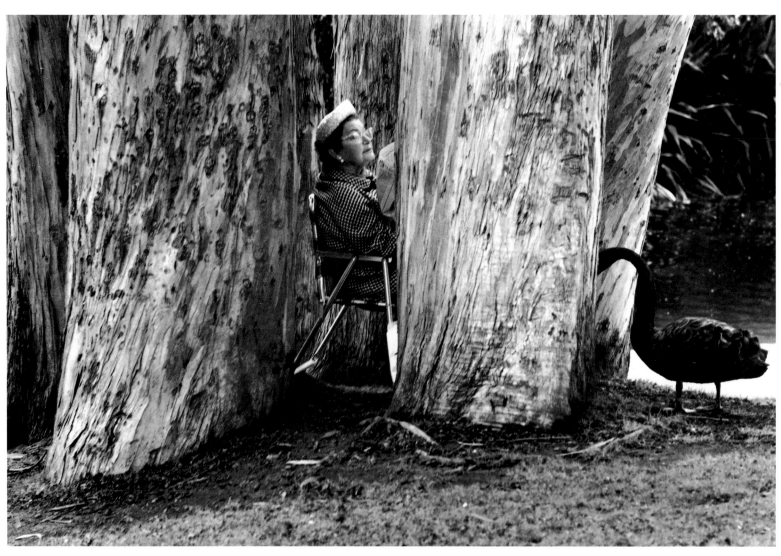

Golden Gate Park

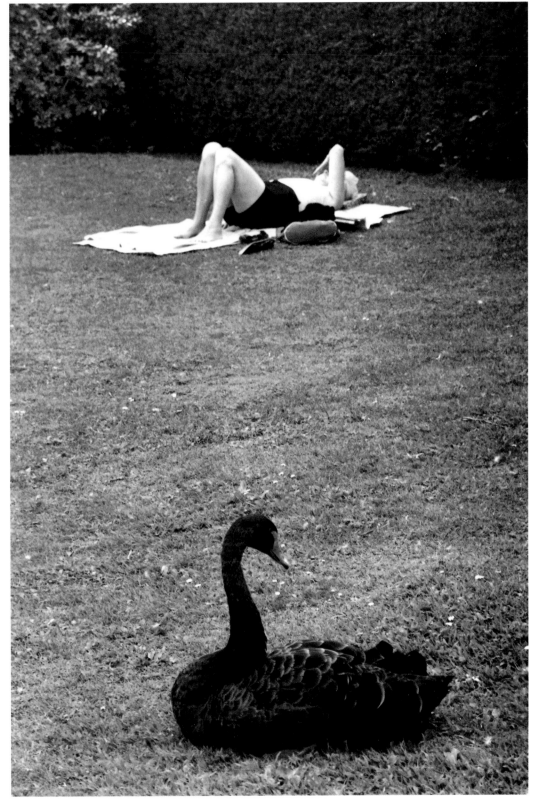

San Francisco Park

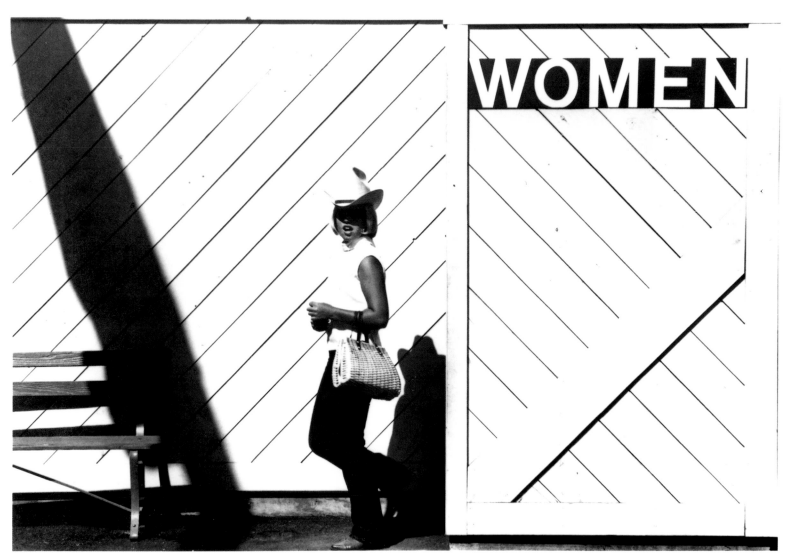

Sacramento state fair Volksfest in Sacramento

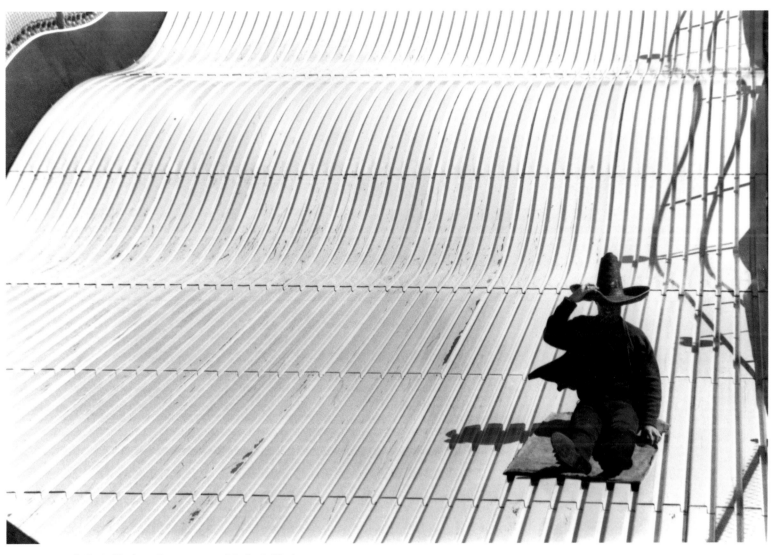

Amusement park, Santa Monica Vergnügungspark in Santa Monica

Space station, Goldenberg

Sunset Boulevard, Los Angeles

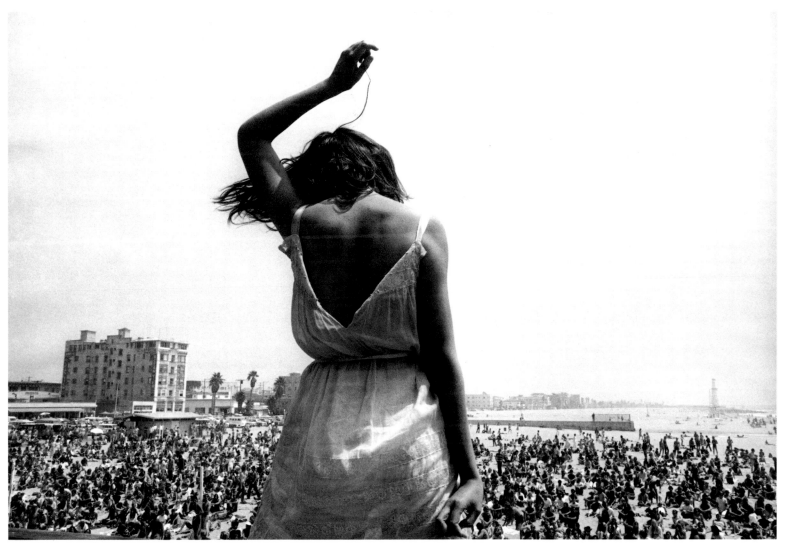

Venice Beach Rock Festival

BIOGRAPHIE / BIOGRAPHY

24. 7. 1928 geboren in New York
1947 – 1951 Lehre bei Gjon Mili
Seit 1951 Mitglied bei Magnum Photos
Lebt in Ménerbes, Frankreich

24/7/28 born in New York City
1947 – 1951 apprentice to Gjon Mili
Since 1951 member of Magnum Photos
Currently resides in Ménerbes, France

AUSZEICHNUNGEN / AWARDS

1951 Erster Preis/First Prize, LIFE Young Photographers
1962 Erster Preis/First Prize, International Photography, Polen/Poland
1991 Erster Preis/First Prize, Advertising Photographers of America

EINZELAUSSTELLUNGEN / SOLO PHOTOGRAPHY EXHIBITIONS

1963 Chicago Art Institute, Ankauf durch die Sammlung/Purchased for permanent collection
1966 Galerie Form, Zürich
1970 De Young Museum, San Francisco
1967 – 1974 Wanderausstellung zum Thema »Sonne«, erste Station Eastman House, Rochester/
Traveling color exhibition on the theme of "The Sun," originating at Eastman House, Rochester
1973 Woodstock Artist's Association, Woodstock, New York
1974 Sony Gallery, Tokyo
1976 Alpha Cubic Gallery, Tokyo
1977 Retrospektive/Retrospective exhibition, International Center of Photography, New York
1985 Photofind Gallery, Woodstock, New York
1987 Urban Gallery, New York
1990 Office Départemental de la Culture, Aix-en-Provence
1992 La Tour Des Cardinaux, L'Isle Sur La-Sorgue
1993 Mitsukoshi, Tokyo, anschließend in weiteren japanischen Städten/
thereafter major cities of Japan through 1994
1994 Schirn Kunsthalle, Frankfurt, Ausstellungstournee/Traveling exhibition

SAMMLUNGEN / MAJOR COLLECTIONS

Art Institute of Chicago
Kunsthaus Zürich
International Center of Photography, New York
Creative Center for Photography, George Eastman House, Rochester
Musée d'Art Moderne, Paris
Fotografiska Museet, Stockholm
National Gallery, Washington, D.C.

GRUPPENAUSSTELLUNGEN / GROUP EXHIBITIONS

1959 »Photography at Mid-Century«, George Eastman House
1960 »The World as Seen by Magnum Photographers«, Wanderausstellung/Traveling exhibition
1962 »Man's Humanity to Man«, Red Cross Centennial, Genf/Geneva
1967 »Photography in the Twentieth Century«, Wanderausstellung des George Eastman House für die
National Gallery of Canada/Traveling exhibition prepared by the George Eastman House for the
National Gallery of Canada
1974 »Photography in America«, Whitney Museum of American Art, New York
1976 und/and 1977 Rencontres internationales de la photographie, Arles
1982 »Magnum Paris«, Palais du Luxembourg, Paris
1983 »Jazz et Photographie«, Musée d'Art Moderne, Paris
1991 – 1992 »In Our Time, Magnum Photographers«, Internationale Wanderausstellung/Worldwide
traveling exhibition

FERNSEHEN / TELEVISION
1991 »Les Robots et L'Homme«, Drehbuch und Regie/Director, writer
1992 »Commune Image James Dean«, Drehbuch, Regie, Co-Produktion/Co-producer, director, writer

DOKUMENTARFILME / DOCUMENTARY FILM
»Efforts to Provoke«, United Artists
»Quest«, Cinema Center, CBS
»British Youth «, NBC

Dennis Stock wurde 1958 im NATIONAL EDUCTIONAL TELEVISION PROFILE und in einer Sendung der NATIONAL ITALIAN TELEVISION (RAI) 1971 vorgestellt/Dennis Stock was the subject of a NATIONAL EDUCTIONAL TELEVISION PROFILE in 1958, and was featured in a program produced by NATIONAL ITALIAN TELEVISION (RAI) in 1971

ZEITSCHRIFTEN / MAGAZINES
PARIS MATCH, GEO, LIFE, LOOK, HOLIDAY, VENTURE, REALITIES, QUEEN, STERN, BUNTE

Veröffentlichungen über Dennis Stock erschienen in/Articles on Dennis Stock have appeared in ASAHI CAMERA (1956), CAMERA (1962, 1967, 1976), MODERN PHOTOGRAPHY (1966), INFINITY (1967), APPLIED PHOTOGRAPHY (1968), ZOOM (1972), NUOVA FOTOGRAFIA (1973), POPULAR PHOTOGRAPHY (1978), DOUBLE-PAGE (1981, 1982), I GRANDI FOTOGRAFI/Fabbri (1982), NEW YORK TIMES MAGAZINE (1984), BRITISH PHOTOGRAPHY (1987), PHOTO DISTRICT NEWS (1991), GRAPHIS (1992).

PHOTOBÜCHER VON DENNIS STOCK / AUTHORED PHOTOGRAPHY BOOKS
1956 »Portrait of a Young Man, James Dean«, Kadakawa Shoten
1959 »Plaisir du Jazz«, La Guilde du Livre
1959 »Jazz-Welt«, Hatje
1960 »Jazz Street«, Doubleday
1963 »The Happy Year«, Text von/Text by Margaret Cabell, Manhasset, N.Y., Channel Press, Inc.
1970 »California Trip«, Grossman
1970 »The Alternative«, Macmillan
1972 »Living our Future: Francis of Assisi«, Franciscan Herald
1972 »Edge of Life: World of the Estuary«, Sierra Club Books
1972 »National Parks Centennial Portfolio«, Sierra Club Books
1974 »Brother Sun«, Sierra Club Books
1974 »California: The Golden Coast«, Viking Press
1974 »Circle of Seasons«, Viking Press
1974 »A Haiku Journey«, Kodansha International
1976 »This Land of Europe«, Kodansha International
1976 »Voyage poétique à travers le Japon d'autrefois«, Bibliothèque des Arts
1978 »Alaska«, Harry N. Abrams Publishing
1978 »James Dean Revisited«, Viking Press/Penguin Books
1980 »America Seen«, Contrejour
1981 »St. Francis of Assisi«, Scala/Harper and Row
1981 »Franziskus: Der Mann aus Assisi«, Reich Verlag, Luzern
1981 »Saint Francis of Assisi«, Frederick Muller, Ltd., London
1986 »Flower Show«, Rizzoli/Magnus
1986 »Impression, Fleurs«, Menges, Paris
1986 »James Dean Revisited«, Schirmer & Mosel, 1987 Chronicle Books
1988 »Provence Memories«, New York Graphic Society/Magnus
1988 »Hawaii«, Harry N. Abrams Publishing
1989 »New England Memories«, Bulfinch Press/Magnus
1994 »Made in USA«, Cantz

ANTHOLOGIEN / ANTHOLOGIES

1961 »Let Us Begin«, Ridge Press
1962 »Creative America«, Ridge Press
1967 »Photography in the Twentieth Century«, Horizon Press
1969 »America in Crisis«, Holt, Rinehardt and Winston
1974 »Photography in America«, Random House
1981 »Paris/Magnum«, Aperture
1990 »In Our Time/Magnum«, Norton
1994 »Magnum Cinema«, Cahiers du Cinéma, Paris Audiovisuelle

WORKSHOPS UND VORTRÄGE / WORKSHOPS AND LECTURES

New York University
International Center of Photography, New York
New School for Social Research, New York
Pratt Institute, New York
State University of New York, Stony Brook
Rencontres internationales de la photographie, Arles
Center for Photography, Woodstock, New York
Art Kane Workshop, Cape May, New Jersey